Sketch Your Style

Editor, ABRAMS edition: Cristina Garces
Cover Design, ABRAMS edition: Robyn Neild and Hana Anouk Nakamura
Production Manager, ABRAMS edition: Elizabeth Peskin
Editor: Lucy York
Designer: Clare Barber

Library of Congress Control Number: 2015952506

ISBN: 978-1-4197-2211-0

First published in Great Britain by Quid Publishing in 2016.
Conceived, designed and produced by
Quid Publishing
Part of The Quarto Group
Level 4, Sheridan House
Hove BN3 1DD

Printed and bound in China
10 9 8 7 6 5 4 3 2 1

ABRAMS
THE ART OF BOOKS SINCE 1949
115 West 18th Street
New York, NY 10011
www.abramsbooks.com

Sketch Your Style

A GUIDED SKETCHBOOK
FOR DRAWING YOUR DREAM WARDROBE

ABRAMS NOTERIE, NEW YORK

CONTENTS

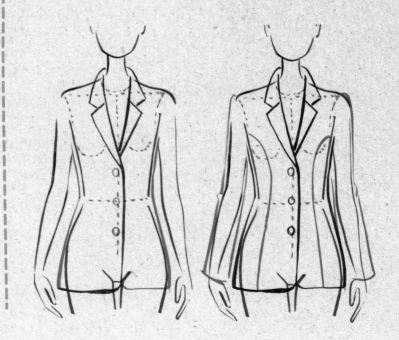

HOW TO USE THIS BOOK

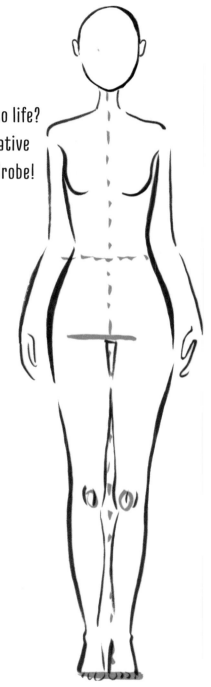

Do you love fashion? Have you always wanted to learn how to bring your fashion ideas to life? Then this is the book for you! *Sketch Your Style* is packed full of style inspiration, creative prompts, and sketching space to start you on the path to creating your own dream wardrobe!

In Part One: Style Sketching, we look at all of the basic tools, drawing techniques, and finishing methods you need to begin your sketching journey. First, you'll learn how to draw "croquis," blank fashion figures that you use as a template for drawing your designs. Croquis can be made in your own likeness so that you can draw clothes that suit your particular body type. From there, we explore the ins and outs of clothing: how to determine fit, how to draw different fabrics, and how to experiment with color. The chapter ends with a Visual Glossary, which illustrates many variations of key wardrobe staples, like pants, shirts, and dresses, for you to reference as you begin to think about what pieces suit you.

Once you understand the basics, you can begin creating your own designs! In Part Two: Style Inspiration, we examine current trends, fashion through the decades, and top designers to give you a range of influences to use when developing your own style. Exploring fashion trends of the moment, like Punk or Bohemian, will help you to identify the elements of popular influences so you can experiment with them in your own designs. Decades in Fashion gives you an insight into the

history of fashion, and how the shapes, fabrics, and colors used in the twentieth century still influence designers today. Designer Icons delves into the works of some of the world's leading fashion designers, like Coco Chanel and Alexander McQueen, who have acted as fashion innovators, changing the rules with their forward-thinking designs and opening our eyes to different ways of dressing.

The final section of the book, Part Three: Sketch Your Style, is all about you! Use the Style Planner to keep a record of the outfits you've worn, or sketch inspirational outfits for upcoming events, be it a wedding, sporting event, or job interview. Then go wild and design a range of outfits for fantastical scenarios, like a gown for an evening at the Oscars, or a costume fit for a crime-fighting superhero. Whatever you decide to do, remember to have fun! Whether you're just starting out or consider yourself a fashion-sketching maven, *Sketch Your Style* will give you all of the tools you need to create your own unique pieces in no time.

PART ONE:
STYLE SKETCHING

Let's talk about the basics! This chapter begins with teaching you how to create your own fashion "croquis"—figure templates onto which you can draw your designs. From there, we look at everything you need to begin to sketch your own garments onto them: the ins and outs of different drawing tools (and the effects you can achieve with each), choosing flattering clothes for your unique body shape, how to draw fabric to change the look and structure of a garment, and working with color. Then we move onto the Visual Glossary, which is a quick reference guide to key wardrobe pieces like skirts, shirts, and accessories, with step-by-step tips for how to create special details like pleats and darts.

TOOLS AND TECHNIQUES

Y ou can use any medium you like to draw your fashion sketches—pencil, felt-tip, marker pen, or ballpoint. Why not try mixing it up and experimenting with the different effects you can achieve with each? Explore a range of pencil leads to discover different methods for creating shading and movement.

✳ Crosshatching can be used to show areas of shading. Create it with the point of a ballpoint, fine pen, or pencil.

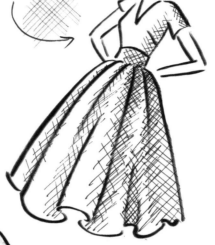

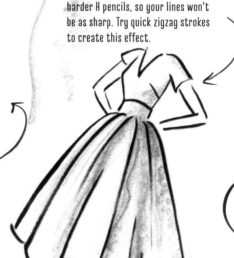

✳ Markers are not so great for fine detail, but ideal for bold strokes and shading. Try using light colors at first to build up confidence. You can always add stronger shades afterward.

✳ For shading and finer detail, try using pastels for a soft finish.

✳ A pencil is a good tool to use for your designs when you first begin because you can erase any mistakes!

✳ For softer shading, try using a softer pencil, B to 5B. This type of pencil will go blunt quicker than harder H pencils, so your lines won't be as sharp. Try quick zigzag strokes to create this effect.

✳ Now try shading with the side rather than the point of the pencil to achieve a smudged, shaded look. Use a harder pencil (HB to 3H) to crosshatch and scribble.

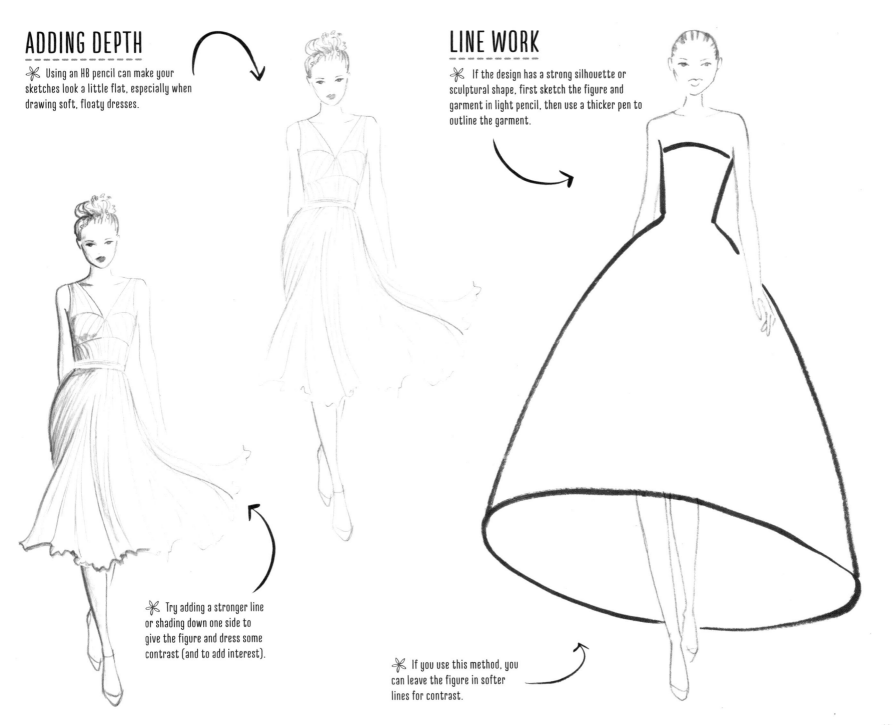

ADDING DEPTH

✳ Using an HB pencil can make your sketches look a little flat, especially when drawing soft, floaty dresses.

✳ Try adding a stronger line or shading down one side to give the figure and dress some contrast (and to add interest).

LINE WORK

✳ If the design has a strong silhouette or sculptural shape, first sketch the figure and garment in light pencil, then use a thicker pen to outline the garment.

✳ If you use this method, you can leave the figure in softer lines for contrast.

HOW TO DRAW A CROQUIS

A fashion croquis is a figure template onto which you can draw your fashion sketches. Bodies come in all shapes and sizes—you can set up your croquis to standard model proportions, or you can adapt it to suit your own body shape.

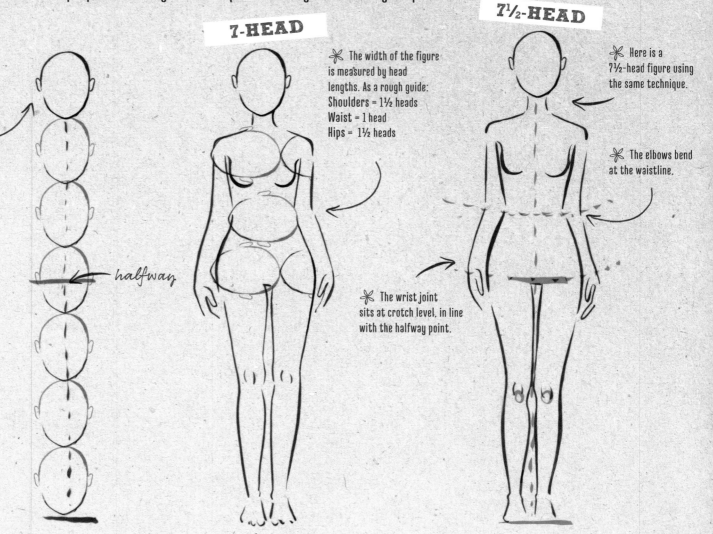

✳ The standard fashion croquis is 8 heads high. If you are more petite, you can make your figure 7 heads tall, as shown here.

1 Draw the head and then measure roughly 6 heads down from the chin to the toes.

2 The halfway point between the top of the head and the toes is where the legs start. This will help you to work out where the important parts of the body should go.

halfway

7-HEAD

✳ The width of the figure is measured by head lengths. As a rough guide:
Shoulders = 1½ heads
Waist = 1 head
Hips = 1½ heads

7½-HEAD

✳ Here is a 7½-head figure using the same technique.

✳ The elbows bend at the waistline.

✳ The wrist joint sits at crotch level, in line with the halfway point.

8-HEAD

8-HEAD

8-HEAD

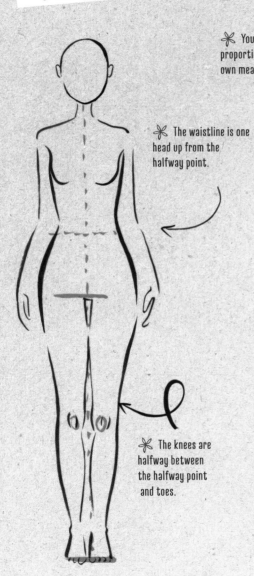

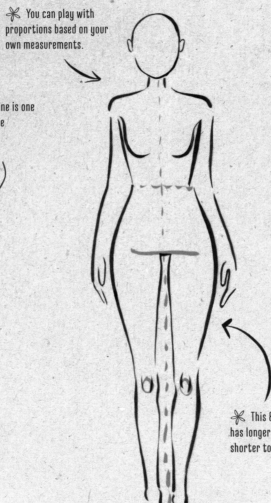

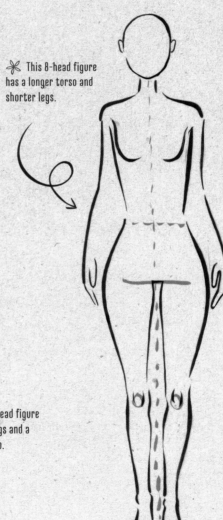

✳ You can play with proportions based on your own measurements.

✳ The waistline is one head up from the halfway point.

✳ This 8-head figure has a longer torso and shorter legs.

✳ The knees are halfway between the halfway point and toes.

✳ This 8-head figure has longer legs and a shorter torso.

KNOW YOUR BODY SHAPE

To help you to design a template figure to fit your own size and shape, take a look at these general body types and work out which category you relate to most or wish to use as your model. Once you have identified your shape, you can decide which clothes will most flatter your figure.

HOURGLASS

FAMOUS HOURGLASSES: Scarlett Johansson and Eva Longoria.

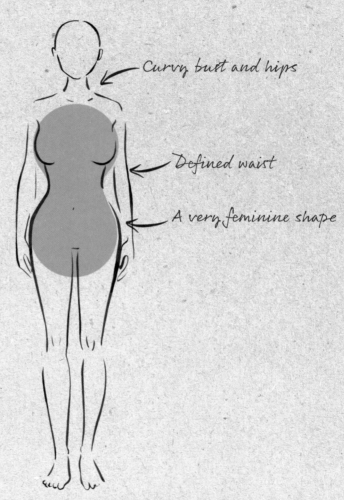

Curvy bust and hips

Defined waist

A very feminine shape

TOPS: V-necks and deep necklines look best. Wrap-around tops enhance the hourglass effect.

SKIRTS: Should hug the hips and show off the curves, and the hem should finish around the knees.

PANTS: Go for flat-fronted, preferably with stretch for good fit, and boot cut.

STYLE TIP: Garments should highlight waist definition.

AVOID: Frills on the bust and high necklines, which make the bust area look too bulky.

PEAR

FAMOUS PEARS: J. Lo, Jennifer Aniston, and Beyoncé Knowles.

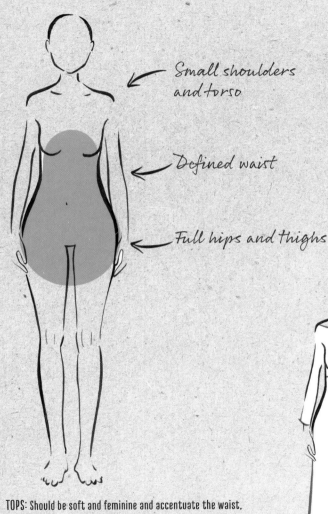

Small shoulders and torso

Defined waist

Full hips and thighs

TOPS: Should be soft and feminine and accentuate the waist, finishing just below the hip bones.
SKIRTS: A-line or circle skirts work best to create more width lower down the leg.
PANTS: Fitted to the waist and bottom, with full, wide legs.
STYLE TIP: Boat and cowl necklines add width to shoulders.
AVOID: Spaghetti straps, deep V-neck tops, tapered shirts, harem pants, and anything that adds extra volume to the waist.

INVERTED TRIANGLE

FAMOUS INVERTED TRIANGLES: Cindy Crawford and Demi Moore.

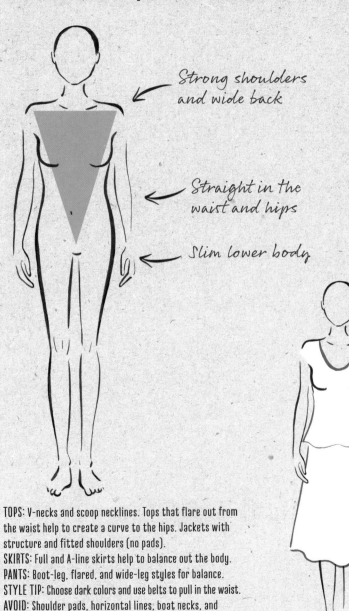

Strong shoulders and wide back

Straight in the waist and hips

Slim lower body

TOPS: V-necks and scoop necklines. Tops that flare out from the waist help to create a curve to the hips. Jackets with structure and fitted shoulders (no pads).
SKIRTS: Full and A-line skirts help to balance out the body.
PANTS: Boot-leg, flared, and wide-leg styles for balance.
STYLE TIP: Choose dark colors and use belts to pull in the waist.
AVOID: Shoulder pads, horizontal lines, boat necks, and anything too short that will make the figure top-heavy.

RECTANGLE

FAMOUS RECTANGLES: Natalie Portman, Gywneth Paltrow, and Cameron Diaz.

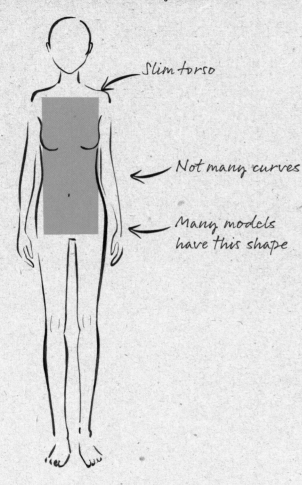

Slim torso

Not many curves

Many models have this shape

TOPS: Off-the-shoulder and boat necklines, embellishments on the shoulders and bust.
SKIRTS: Knee-length pencil skirts that taper, A-line, tiered, bubble, or full skirts, and skirts with seams or pockets to create the illusion of curvy hips.
PANTS: Cargo or safari pants with pronounced hip and rear pockets.
STYLE TIP: Use strong color blocks to define the body.
AVOID: Shapeless garments.

APPLE

FAMOUS APPLES: Jennifer Hudson, Catherine Zeta-Jones, and Drew Barrymore.

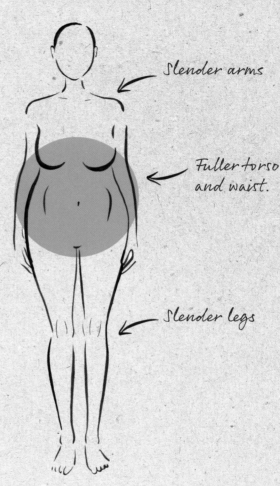

Slender arms

Fuller torso and waist.

Slender legs

TOPS: Pick tops that fit at the slimmest part of the torso (probably under the bust). V-neck tops will break up the space of the chest.
SKIRTS: Structured knee-length pencil skirts.
PANTS: Flared or straight.
STYLE TIP: Empire waist garments in fun patterns are most flattering.
AVOID: Clingy fabrics.

Now practice drawing your own croquis.

ADDING DETAILS TO YOUR FIGURES

FACE

You can make your fashion figures really come to life by adding in details like facial features and hair (see opposite). Here is a rough guide to use when creating a face.

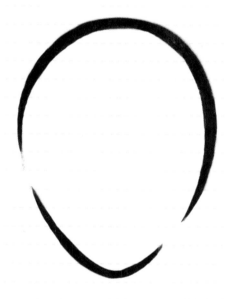

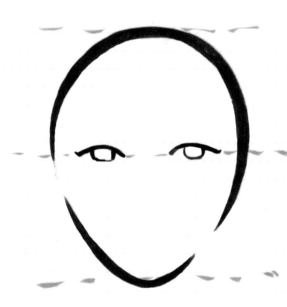

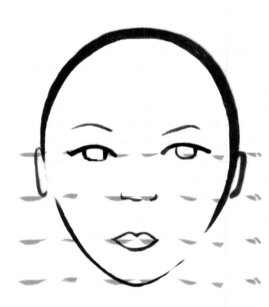

1 Start with the outline. Draw an oval egg-like shape, with the narrower part at the bottom.

2 Figure out the halfway mark—this is eye level (shown in dotted blue line).

3 Now divide the bottom half of the face into thirds. At the bottom of the first third, draw the bottom of the nose. At the second, draw in the mouth. The ears fall between eye and nose level.

HAIR

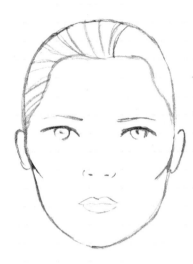

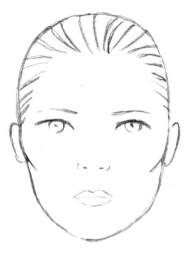

1 The hairline starts around one-third of the way down the space between the top of the head and the eyebrows. Use the red lines as a guide.

2 Drawn in blue is a rough outline of the hairline. It is something between a square and a semicircle.

3 The hair is tied back in this example. Draw curved rather than straight lines for the hair. At the sides of the head, angle the lines down.

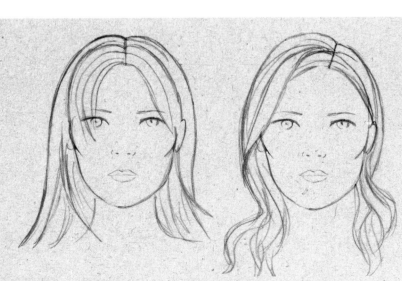

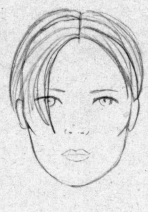

✳ What type of hair and style do you want to draw? Is it curly or straight, sleek or textured? Think of drawing your lines like you'd comb your hair, so that the hair flows in a natural way. Start at the part and work downward. Use an HB pencil so that the lines are pale and defined.

Use these pages to practice
sketching faces and hair.

HOW FABRIC WORKS

The type of fabric a garment is made of radically affects how it looks and hangs. When trying to capture the specific qualities of a fabric, economy of line will give the best results. First, think about the fabric: silk crepe is soft and flowing and so the lines need to be curvy and slow; taffeta is crisp, calling for jagged, broken lines; tulle and netting are starchy and stand away from the body, so quick, fine lines are needed.

HOW'S IT HANGING?

The same full skirt design can look very different, depending on what fabric it is made of.

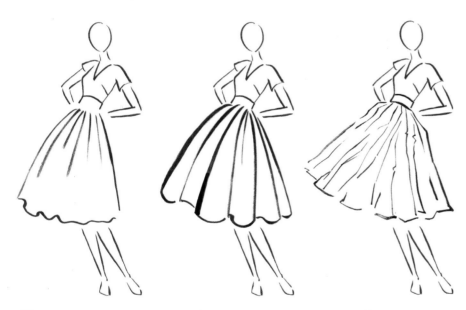
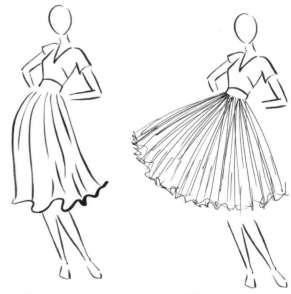

1 Cotton hangs slightly away from the body, but has movement and some softness. Use slightly curved thin lines. The fabric flows from the gathered waist to the bottom of the hem.

2 Heavy, thick wool hangs in big, curved folds. Use thicker, curved, and stiff lines that flow right to the hemline.

3 Taffeta is a crispy and thin fabric that crumples easily, so go for lots of broken lines that change direction (a bit like drawing lightning). Think of the quality a paper bag has.

4 Silk crepe is soft and flows on the body—it has more "swish" movement. Draw curved lines in elongated "C" and "S" shapes, and no straight lines.

5 Tulle and netting are the starchiest fabrics. They stand away from the body, like the skirt of a ballerina. Strong, quick lines work best in pencil or fine marker.

BIAS CUT

Some garments have a "bias cut": this means that a garment is cut on the diagonal of the fabric's grain (the direction in which the threads composing the fabric run). Bias cut makes the fabric more elastic, so that it clings to the curves of the body. This was the technique used often in the glamorous dresses worn by the silver screen film stars from the 1930s and 1940s.

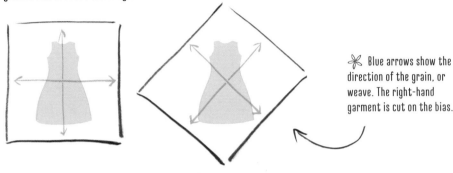

✻ Blue arrows show the direction of the grain, or weave. The right-hand garment is cut on the bias.

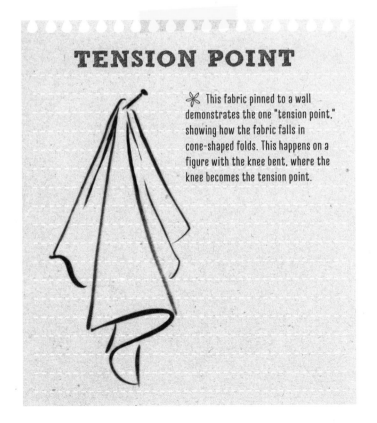

TENSION POINT

✻ This fabric pinned to a wall demonstrates the one "tension point," showing how the fabric falls in cone-shaped folds. This happens on a figure with the knee bent, where the knee becomes the tension point.

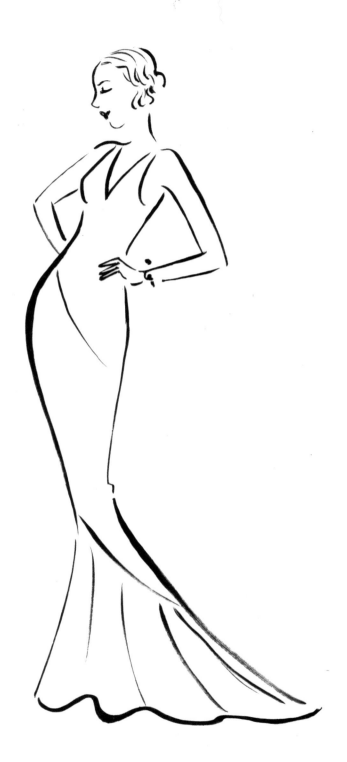

USING COLOR

Complete your look by adding color to the garments you've designed. Color is key when it comes to clothes. Every season welcomes a new color palette onto the catwalks and into the fashion stores. During the summer, hot pink and orange might be the colors to wear. In the fall, purples are popular, and in winter, metallics. Pastels and grays are always trendy for spring.

COLOR WHEEL

Pick out your accent color and then choose colors that either harmonize with it or "pop" next to it.

COLOR WHEEL

This color wheel will help you to explore color. In this wheel there are 12 hues.

PRIMARY

There are three primary colors: red, yellow, and blue. These are the "pure" colors that make up all the other colors.

SECONDARY

Secondary colors (green, orange, and purple) are a blend of two primary colors.

TERTIARY

Tertiary colors are combinations of one primary and one secondary color.

COMPLEMENTARY

The colors opposite each other on the color wheel complement each other. These colors look quite dramatic when used together.

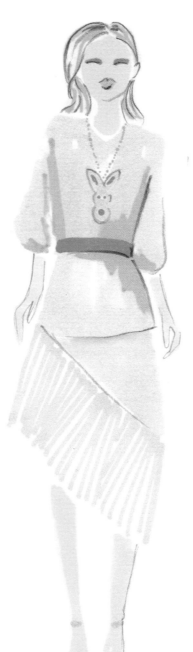

ANALOGOUS

Colors that sit adjacent to each other on the color wheel are a less dramatic, but equally appealing, combination.

✻ Try contrasting colors that "pop." If you wear a soft gray dress with a brightly colored belt (think pink or yellow), it will really sing!

MONOCHROMATIC

The same color in varying shades.

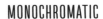

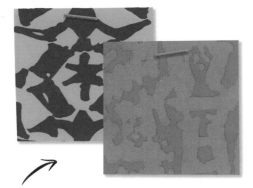

✻ These fabric patterns use complementary colors for dramatic effect.

✻ A stylish bag in different shades of purple.

25

❋ Use this page to experiment with drawing a dress or skirt in different fabrics (see page 22).

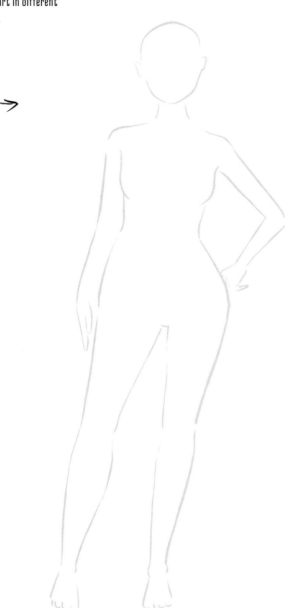

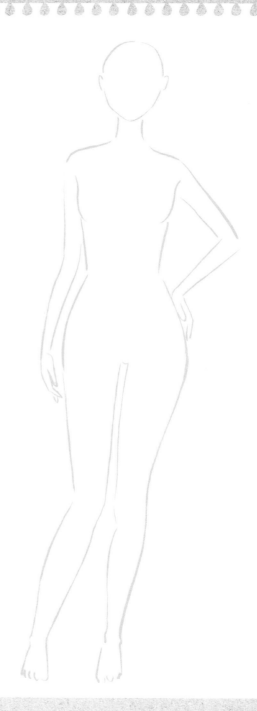

✳ Use this page to experiment with color. Try creating your own fabric swatches in complementary, analogous, and monochromatic color schemes (see page 25).

VISUAL GLOSSARY
DRESSES

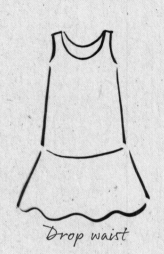

Drop waist

Tent

Empire

Mermaid

Trapeze

Bell

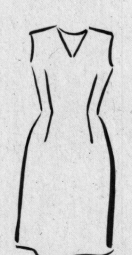

Sheath

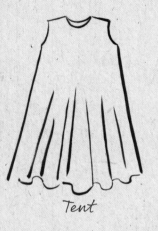

Wrap

Bubble

Princess

Shirt

DRAWING DARTS ON DRESSES

Darts are essential for a fitted look. They are found in women's tailoring on areas of the body that have the greatest curve—the bust, and waist to hip. Look at the dress shapes below and notice how the darts and seams have helped to shape the designs. Let's practice drawing darts to shape your dress designs by using a simple shift dress.

✳ A shift dress is the most basic dress design, with no sleeves, a round neckline, and just two darts to add fit under the bust. The following three examples show other ways of adding fit using darts or seams.

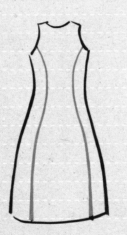

✳ Similar to the first example, this adds fit to the bust.

✳ A dress with two perpendicular darts takes fullness away from the waist and finishes before the bust and hip.

✳ This dress has the most fit. The two seams running from the armhole, along the bust, to waist, hips, and down to the hemline pulls in the fabric throughout.

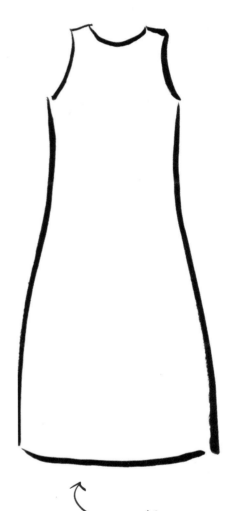

✳ Add darts to create the fit you want. Consider the contours of your specific shape.

SKIRTS

Peplum

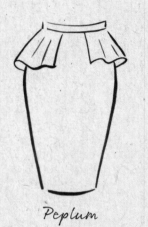

Maxi

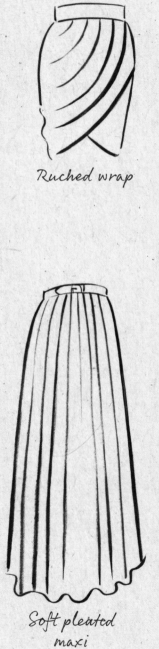

Ruched wrap

Panel

Pleated

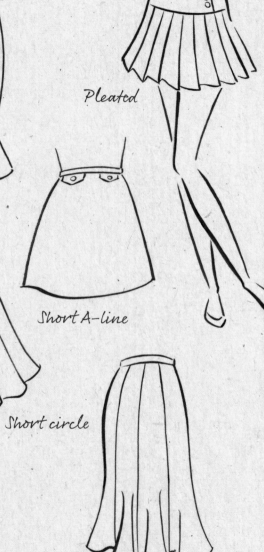

Long A-line

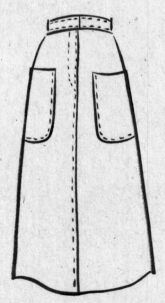

Soft pleated maxi

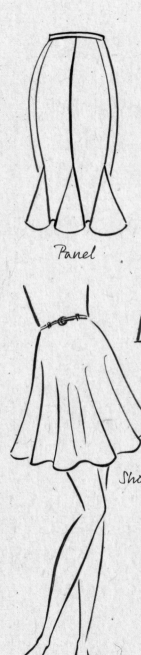

Short A-line

Short circle

Trumpet

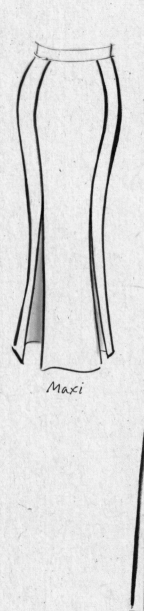

DRAWING A FULLY FLARED SKIRT

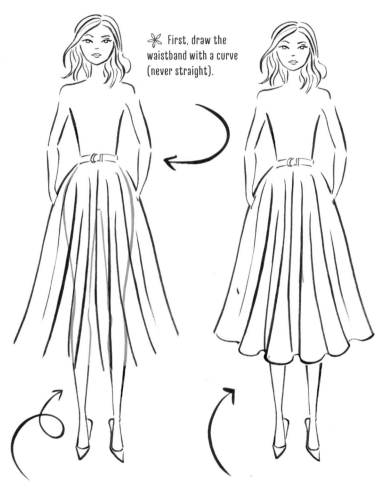

✳ First, draw the waistband with a curve (never straight).

✳ Add the vertical folds and shadows of the skirt (the fabric here is soft wool). Try not to draw them too straight. They should start right below the waistband to avoid too much bulky fabric around the waist.

✳ Finally, draw the fluted folds of the hemline, joining the bottoms of the vertical fold lines with a wavy line. Remember: the type of fabric will affect the size of the folds.

✳ Now try sketching your own fully flared skirt.

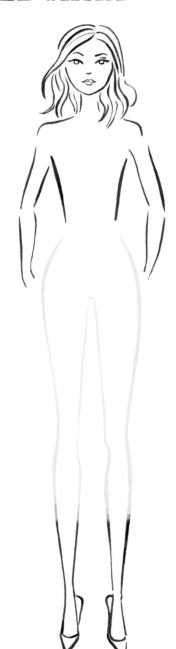

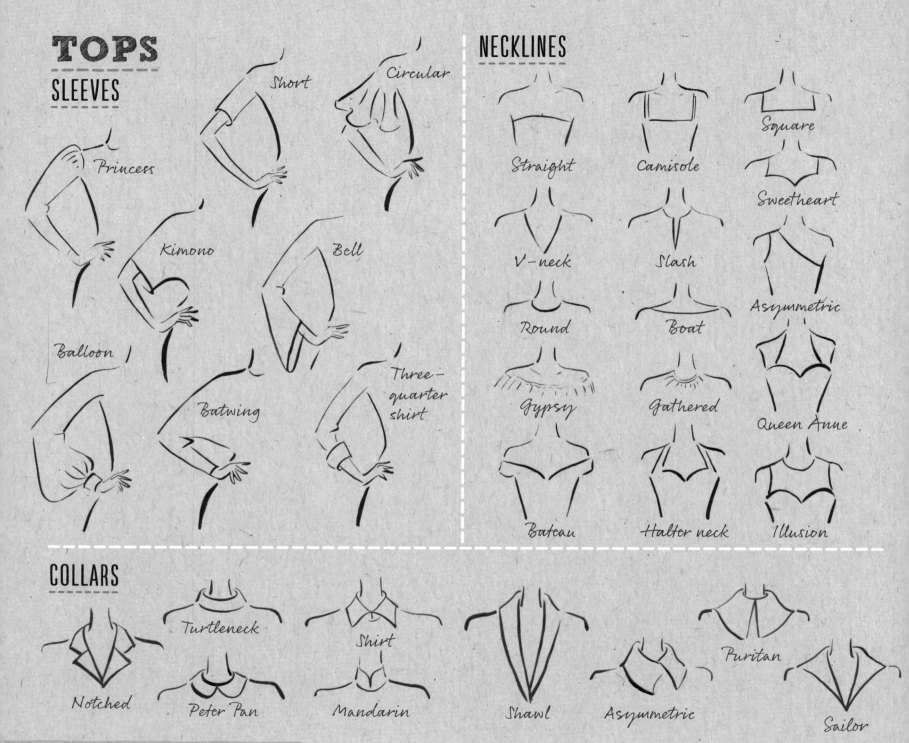

TOPS

SLEEVES

Princess

Short

Circular

Kimono

Bell

Balloon

Batwing

Three-quarter shirt

NECKLINES

Straight

Camisole

Square

V-neck

Slash

Sweetheart

Round

Boat

Asymmetric

Gypsy

Gathered

Queen Anne

Bateau

Halter neck

Illusion

COLLARS

Notched

Turtleneck

Peter Pan

Shirt

Mandarin

Shawl

Asymmetric

Puritan

Sailor

DRAWING A SHIRT

1 Start by drawing the torso. Lightly mark in pencil the neck hole, arm hole, waist, and center line (cut the figure in half vertically, drawing a line from the middle of the neckline, through the bust, belly button, and crotch). These marks (shown in dotted blue lines) will help when designing the shirt. Work out how high you want the collar to be and how the garment opens (shown in red).

2 Draw the rest of the collar and placket (the opening).

3 Now define the shape of the bodice and sleeves. Is it structured, with seams, or loose and baggy?

4 Complete the sketch by adding drape and fold lines at the waist, elbow, and cuff.

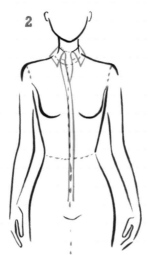
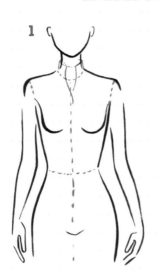
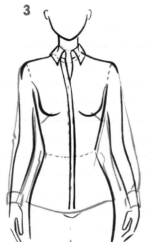
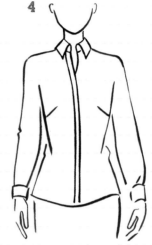

DRAWING A NOTCHED COLLAR

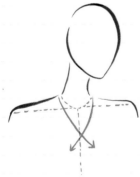
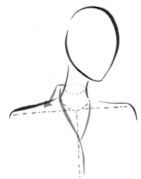

1 The dotted blue lines show the reference points of the center line, neck hole, and shoulder line. These will help you to place the collar so it "sits" correctly on the figure. In red you can see the opening for the shirt and the overlap.

2 Next, mark in the height you want the collar to be on the neck. Not too high—most collars only go about a quarter of the way up the neck (think how uncomfortable it would be to wear if they went much higher). Draw the angle of the collar to the shoulder line.

3 Now work out where you want to place the top collar and where the notch will be (where the top and lower collars join). It is usually halfway between the nape of the neck and the bottom of the opening (marked with an orange dot).

4 Finally, draw in the bottom collar.

PANTS

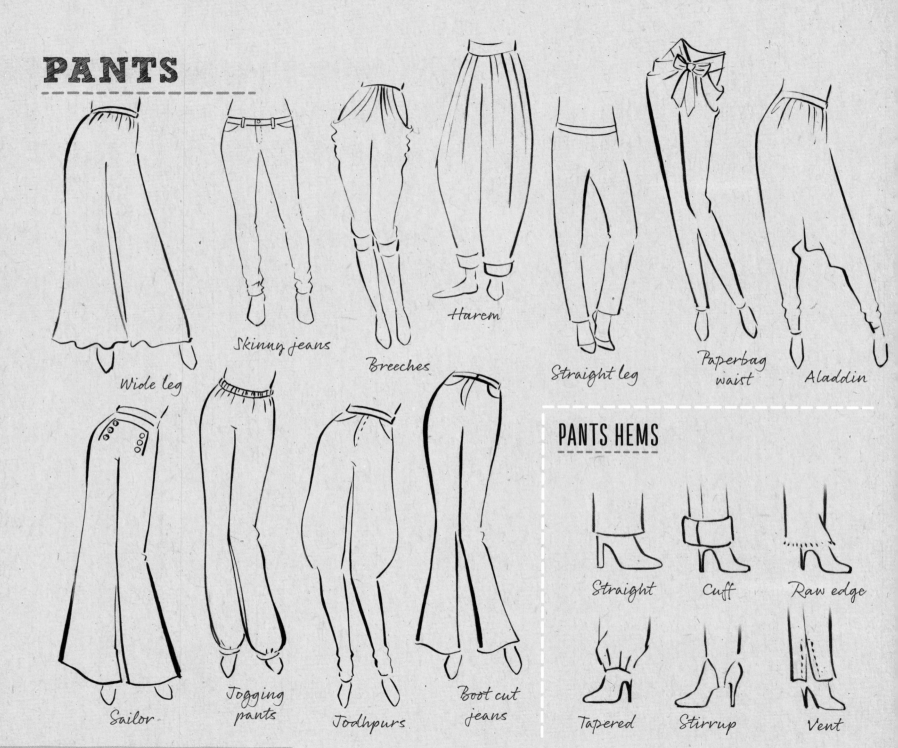

Wide leg

Skinny jeans

Breeches

Harem

Straight leg

Paperbag waist

Aladdin

Sailor

Jogging pants

Jodhpurs

Boot cut jeans

PANTS HEMS

Straight

Cuff

Raw edge

Tapered

Stirrup

Vent

DRAWING PANTS

1

1 Draw the outline of the legs in a standing pose with a pencil.

2

2 Add some markers to help create the general outline of the pants. Draw in the waistband using a curved line (never a straight line). Next add the center front line from the middle of the waistband down to the crotch. Then draw the creases where the legs meet the torso (crotch to hip) and then mark the fullness of the pants on the thighs and calves.

3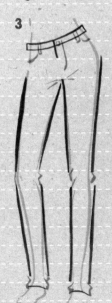

3 Now add more details to your design—the opening and buttons or other fastenings. This is a jeans-inspired design so it needs a fly, pockets, and belt loops on the waistband. To make the drawing realistic, show where the creases occur. Add a few to the crotch, radiating out, as well as on the knees and at the bottom hemlines, but don't add too many.

4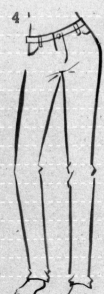

4 Finally, go over the design with a ballpoint or a fine brush and erase the pencil marks.

 Draw your own design using the waistbands and pocket details given as your starting point. Remember to use the knee area as your reference guide. The amount of fullness you add to the garment is your choice.

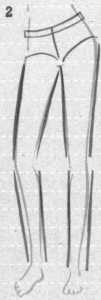

SHORTS

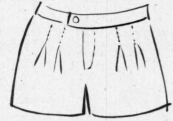

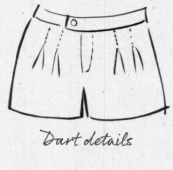

Dart details

High-waisted

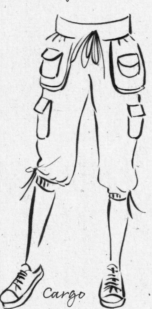

Flared

Short shorts

Gym

Cargo

Button waistband
and cuffs

POCKETS

Jeans

In-seam

Cargo

Slash

Preppy

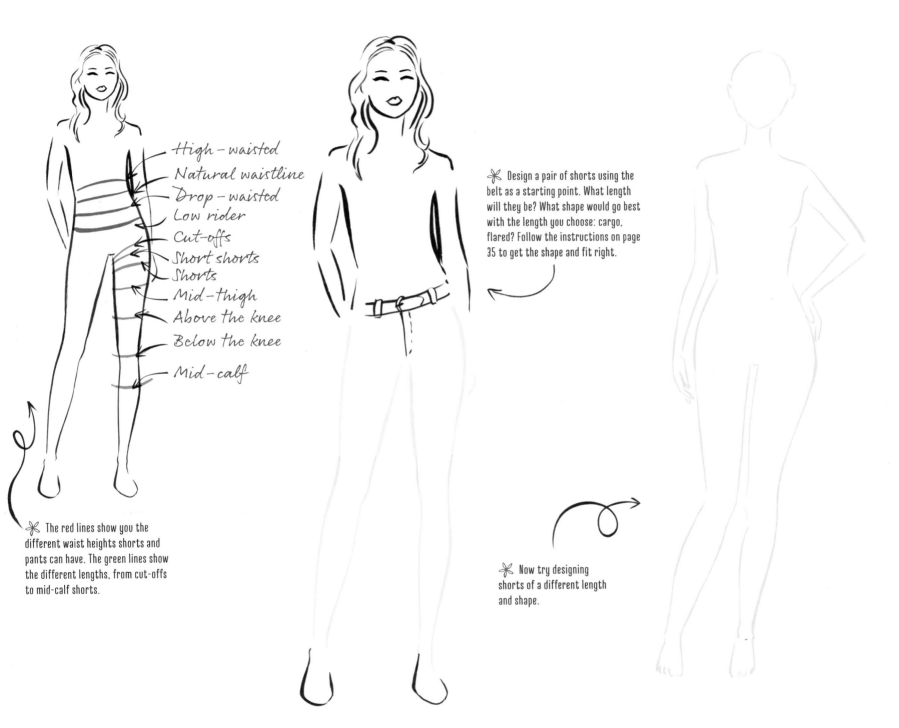

High – waisted
Natural waistline
Drop – waisted
Low rider
Cut-offs
Short shorts
Shorts
Mid – thigh
Above the knee
Below the knee
Mid – calf

✿ The red lines show you the different waist heights shorts and pants can have. The green lines show the different lengths, from cut-offs to mid-calf shorts.

✿ Design a pair of shorts using the belt as a starting point. What length will they be? What shape would go best with the length you choose: cargo, flared? Follow the instructions on page 35 to get the shape and fit right.

✿ Now try designing shorts of a different length and shape.

37

COATS

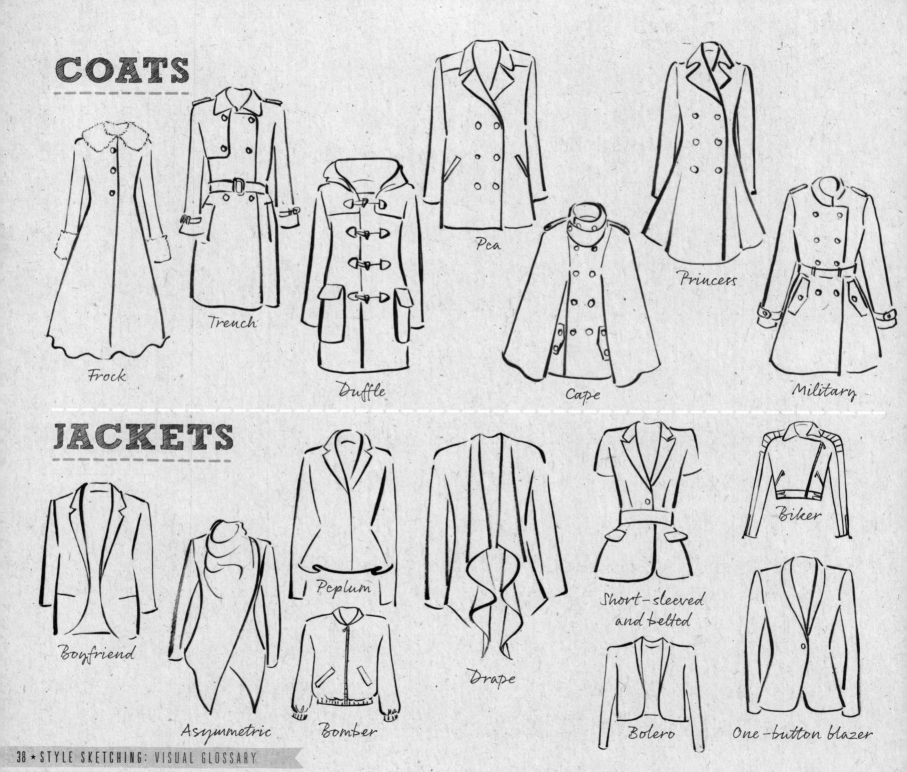

Frock

Trench

Duffle

Pea

Cape

Princess

Military

JACKETS

Boyfriend

Asymmetric

Peplum

Bomber

Drape

Short-sleeved and belted

Bolero

Biker

One-button blazer

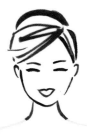

✳ You can design a coat that fits or distorts your silhouette by using different effects. This coat exaggerates the silhouette of the figure by nipping in at the waist and standing away from the body on the hips and thighs (shown in pink).

✳ Design your own coat. You can go super fitted, add special detail to the shoulders, or go for something different with an asymmetric design! Look at the shapes opposite for some ideas.

DESIGN A JACKET

1 Draw your figure and mark the neck and arm holes, the center front, the waist and shoulder lines, and the bust area (shown here with blue dotted lines).

2 Work out the collar design and how low you want the jacket opening to be (usually bust height on the average blazer). Remember to draw the collar curving around the back of the neck so it looks like it goes behind the neck and wraps around.

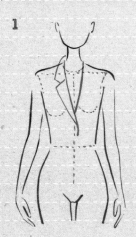

1

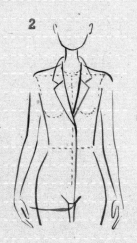

2

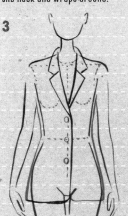

3

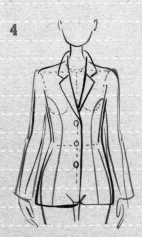

4

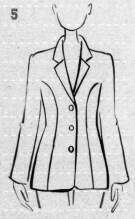

5

3 Draw the jacket's center front further over than the body's center front, so the buttons can be central. Draw the other side of the collar. Work out what length you want the jacket to be (usually around crotch level). Mark in the buttons.

4 Complete the sleeve design. Define the outline of the bodice part of the jacket to show the fit. This jacket has "princess" seams to add extra fit—starting at the armhole, going across the bust, down to the waist and the hemline.

5 The finished look.

SHOES

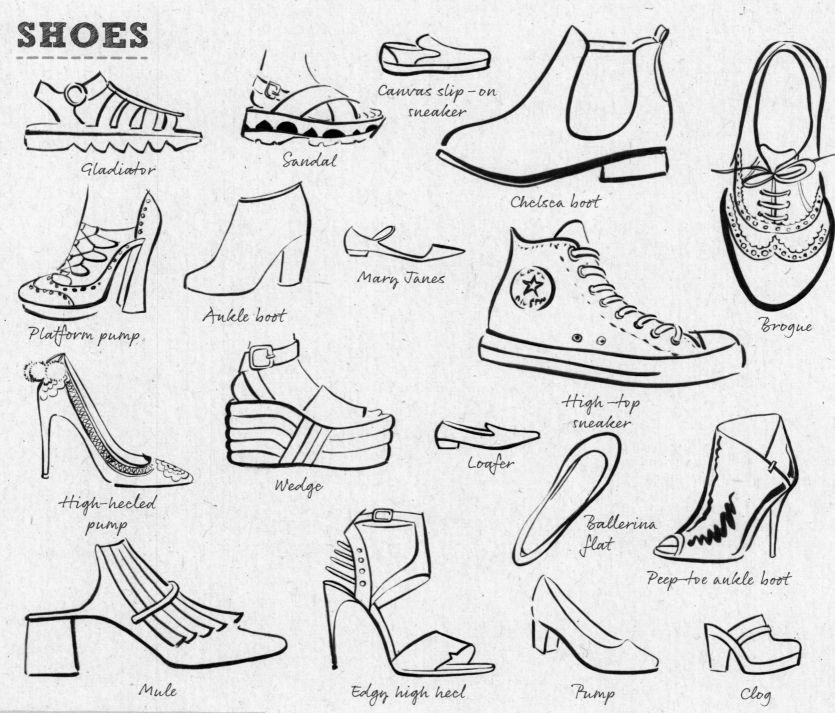

Gladiator

Sandal

Canvas slip-on sneaker

Chelsea boot

Brogue

Platform pump

Ankle boot

Mary Janes

High-top sneaker

High-heeled pump

Wedge

Loafer

Ballerina flat

Peep-toe ankle boot

Mule

Edgy high heel

Pump

Clog

BASIC SHOE SHAPES

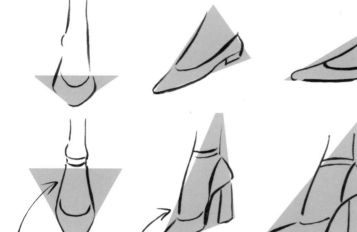

✳ The basic shape of any shoe is a triangle.

✳ The higher the heel, the taller the triangle.

✳ When viewing the foot sideways, the sole will rest on the bottom of the triangle.

✳ Use the triangle method to draw a flat shoe and a high heel.

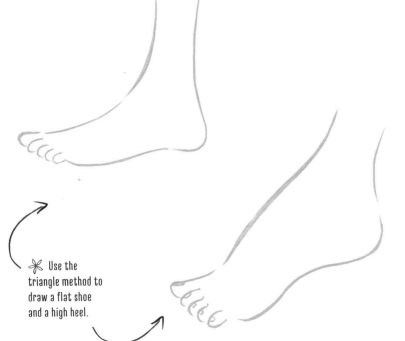

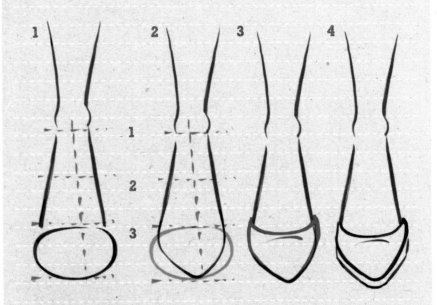

FOOT PROPORTIONS

Here is another way of working out the proportions of the foot and shoe:

1 From the ankle bone, divide the foot into thirds (shown in dotted blue lines). For the first two-thirds, draw straight lines for the outline of the foot getting wider (shown in black), then draw a flattened "0."

2 This is a right foot, so the big toe is on the right. Mark the space needed for the big toe. The rest of the toes will fit into the remaining space (divided area shown in dotted red).

3 Use the flattened "0" shape and dotted red lines as your reference to draw the toe shape of the shoe. Draw the top of the shoe (shown in red).

4 Finish by drawing the sole of the shoe.

BAGS

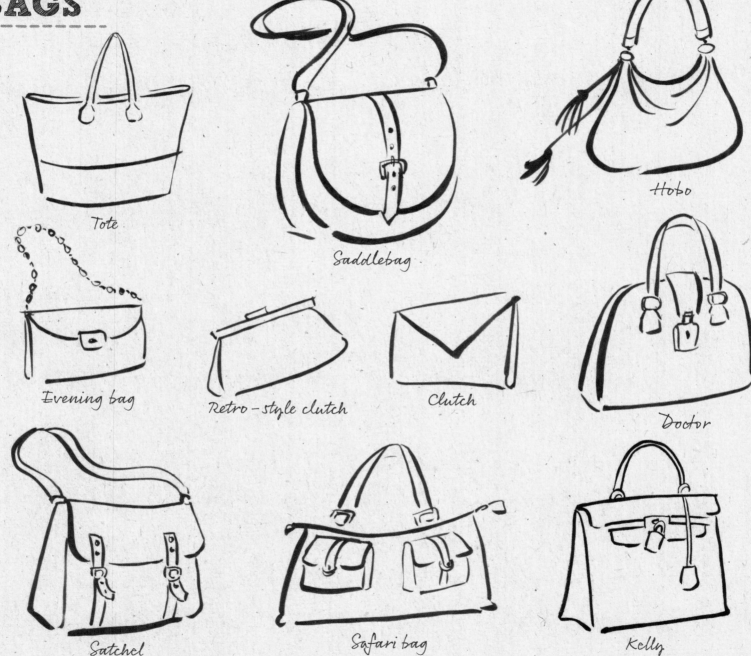

Tote

Saddlebag

Hobo

Evening bag

Retro-style clutch

Clutch

Doctor

Satchel

Safari bag

Kelly

DESIGN A BAG

1 Draw the rough rectangle shape of your bag and mark the halfway point. It is best to draw the bag from an angle so you see it in 3D and get a feel for how big it is. The side nearest to you (left side) will appear bigger than the other side (right).

2 Draw in the basic shape of the bag. Think about the way you want the bag to open—is there a flap, and if so, how far down does it reach?

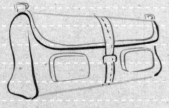

3 Now add in more detail. Add pockets, buckles, and straps. This is a design for a messenger-style bag, so it has a shoulder strap and flap, with a buckle strap.

4 Mark in where the topstitching should go, if needed.

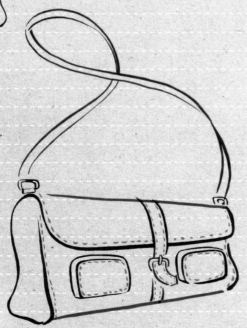

DRAWING LINKS

Many bags use links in their straps, either to connect the strap to the bag, or as decoration.

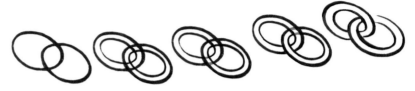

1 Draw two overlapping links (ovals) in pencil.

2 Draw a smaller oval inside each oval.

3 Where the links overlap, erase some of the lines to make the links look like they are joined. On the top link erase the lines in red, to put the left side behind.

4 To make the right side on top, erase the lines marked in red.

✳ Practice drawing links here. Turn to page 44 for space to design a bag.

 Use this page to practice designing a bag (see page 43).

 Use this page to practice drawing a shirt (see page 33) and designing a jacket (see page 39).

PART TWO:
STYLE INSPIRATION

Even the top fashion designers will admit that they have outside influences. This part of the book is packed with inspiration that you can draw on when creating your fashion sketches, with plenty of exercises to help you to incorporate the ideas into your own designs. Starting with Fashion Trends, we look at some key recurring looks. Then it's time for a trip down memory lane with Decades in Fashion, from the art-deco splendor of the 1920s to the mash-up fashions of the 2000s. Finally, the Designer Icons section introduces six iconic designers who have left their mark on the world of fashion.

FASHION TRENDS

BOHO

Bohemian fashion is a vintage-inspired look. Casual, romantic, and eclectic, it is often worn by celebrities such as Sienna Miller and Nicole Richie, and many a festival goer! It combines the 1970s free-spirited vibe with a world traveler feel, as if you've collected different pieces from your travels—African prints, Indian bangles, and Moroccan shawls. Think layers, gathered skirts, beads, and bangles. Fabrics can be floaty chiffons or printed and embroidered cottons and velvets.

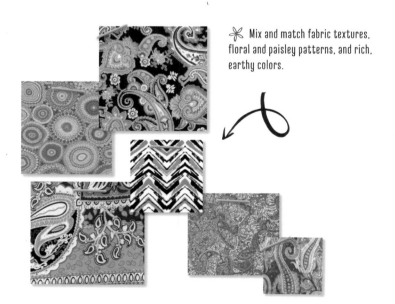

✳ Mix and match fabric textures, floral and paisley patterns, and rich, earthy colors.

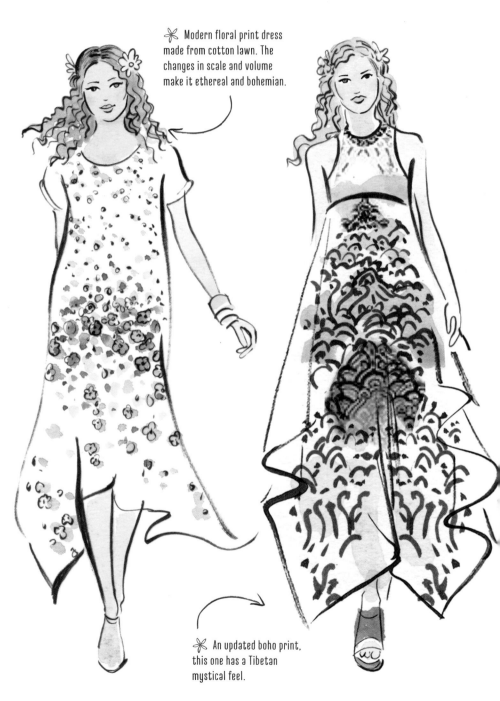

✳ Modern floral print dress made from cotton lawn. The changes in scale and volume make it ethereal and bohemian.

✳ An updated boho print, this one has a Tibetan mystical feel.

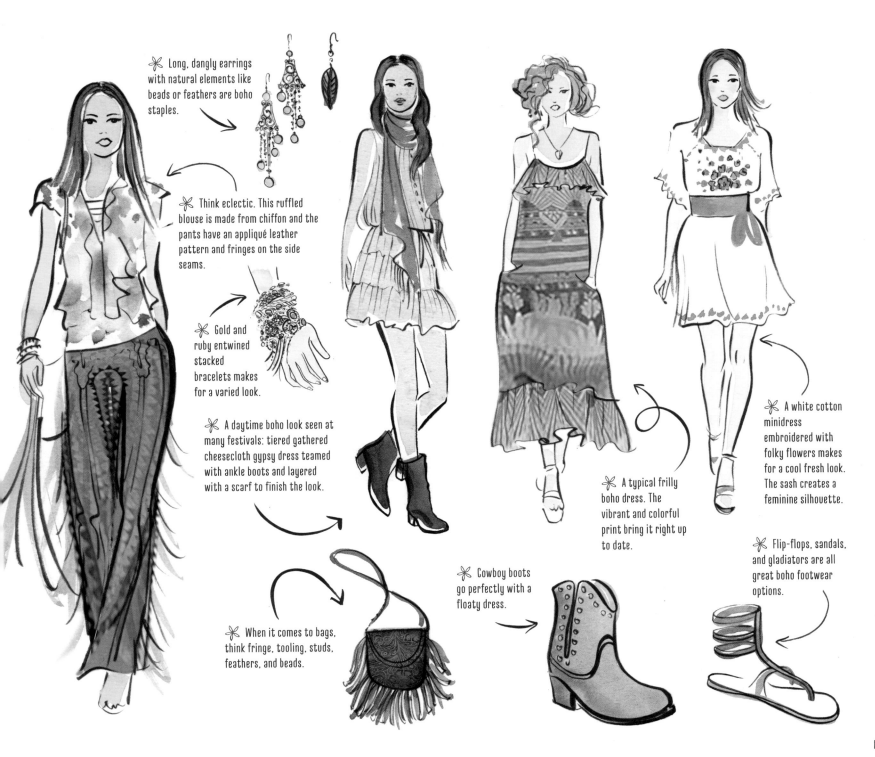

❋ Long, dangly earrings with natural elements like beads or feathers are boho staples.

❋ Think eclectic. This ruffled blouse is made from chiffon and the pants have an appliqué leather pattern and fringes on the side seams.

❋ Gold and ruby entwined stacked bracelets makes for a varied look.

❋ A daytime boho look seen at many festivals: tiered gathered cheesecloth gypsy dress teamed with ankle boots and layered with a scarf to finish the look.

❋ When it comes to bags, think fringe, tooling, studs, feathers, and beads.

❋ A typical frilly boho dress. The vibrant and colorful print bring it right up to date.

❋ Cowboy boots go perfectly with a floaty dress.

❋ A white cotton minidress embroidered with folky flowers makes for a cool fresh look. The sash creates a feminine silhouette.

❋ Flip-flops, sandals, and gladiators are all great boho footwear options.

49

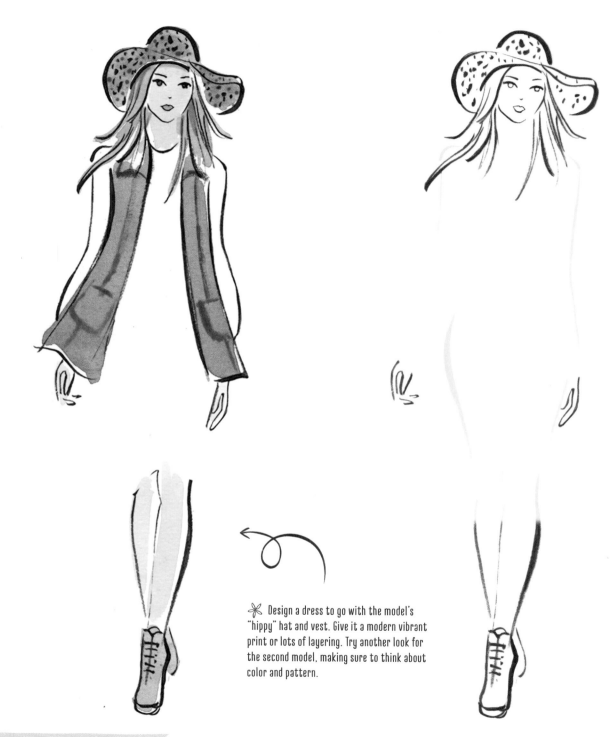

✤ Design a dress to go with the model's "hippy" hat and vest. Give it a modern vibrant print or lots of layering. Try another look for the second model, making sure to think about color and pattern.

❋ Now try a look for you!

❋ The gorgeous model below has voluminous textured hair and is wearing shades. Design her a modern boho look. You could use the print above as a starting point for your design. Consider adding some tassels and fringe to complete the boho vibe.

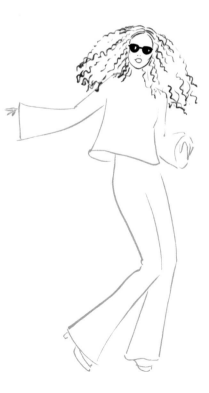

✳ Now try a look for you!

✳ Create a design for this model, who is wearing a fedora and knee-high boots. Perhaps shorts or a minidress would go well with her ensemble?

✽ Design an outfit for a festival goer. Your design could have lots of layers or be a long floaty dress made from a fabric like cotton. Use the swatches for color and pattern inspiration (and don't forget the accessories!).

ROCK

The rock chick look is all effortless attitude—icons Patti Smith, Chrissie Hynde, and Debbie Harry epitomized this look. Combine a pair of tight leather jeans or a miniskirt with tousled hair and smudged eyeliner. Take inspiration from the styles and fabrics used for men's clothing—think tight jeans, cut-off T-shirts, studded belts, and vintage military jackets. Keep skirt hemlines short and dress up the look with high-heeled shoes or edgy boots.

✳ Animal prints, stars and stripes, and metallics are combined with fabrics such as denim and faux leather.

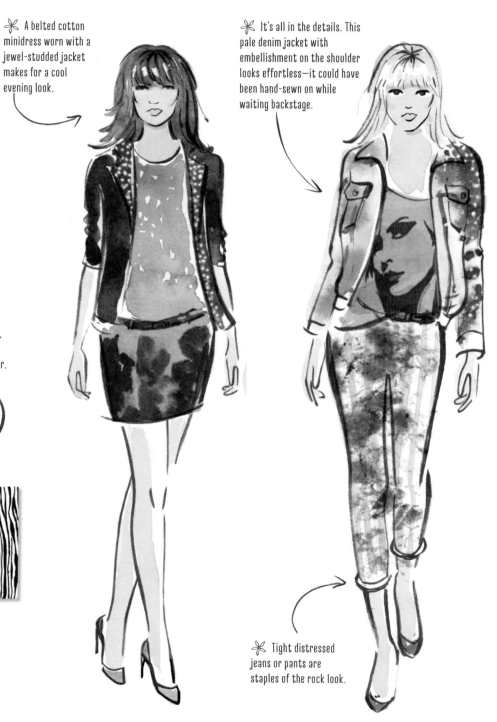

✳ A belted cotton minidress worn with a jewel-studded jacket makes for a cool evening look.

✳ It's all in the details. This pale denim jacket with embellishment on the shoulder looks effortless—it could have been hand-sewn on while waiting backstage.

✳ Tight distressed jeans or pants are staples of the rock look.

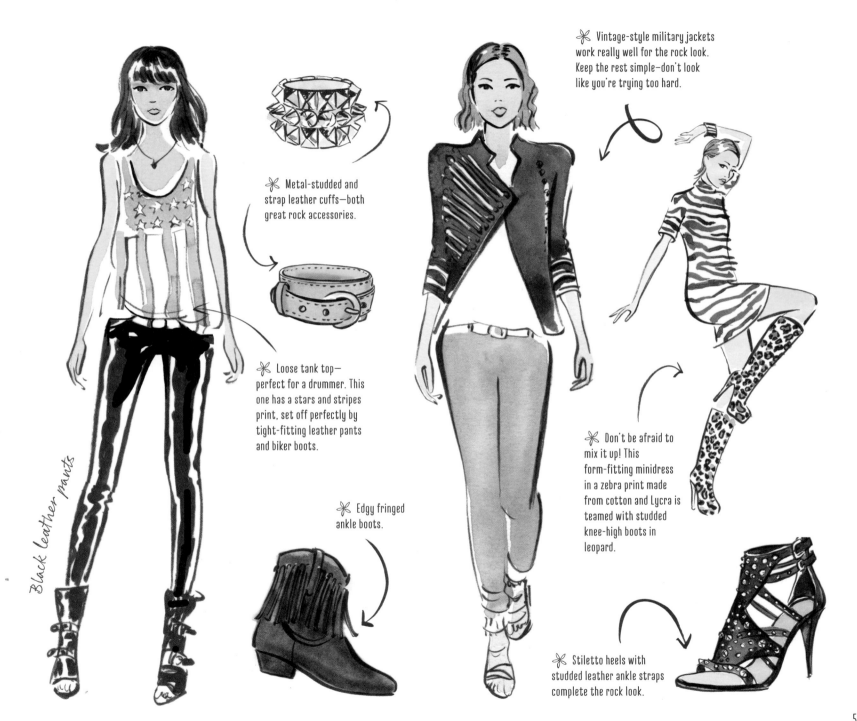

✳ Metal-studded and strap leather cuffs—both great rock accessories.

✳ Loose tank top—perfect for a drummer. This one has a stars and stripes print, set off perfectly by tight-fitting leather pants and biker boots.

Black leather pants

✳ Edgy fringed ankle boots.

✳ Vintage-style military jackets work really well for the rock look. Keep the rest simple—don't look like you're trying too hard.

✳ Don't be afraid to mix it up! This form-fitting minidress in a zebra print made from cotton and Lycra is teamed with studded knee-high boots in leopard.

✳ Stiletto heels with studded leather ankle straps complete the rock look.

 Design the top to go with this rock chick's leather pants and high heels.

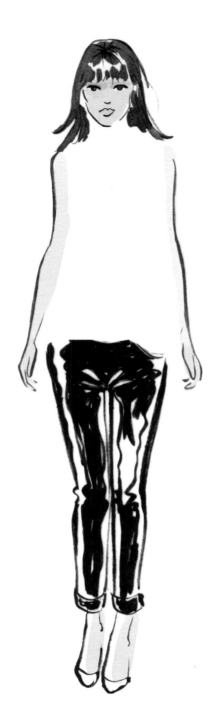

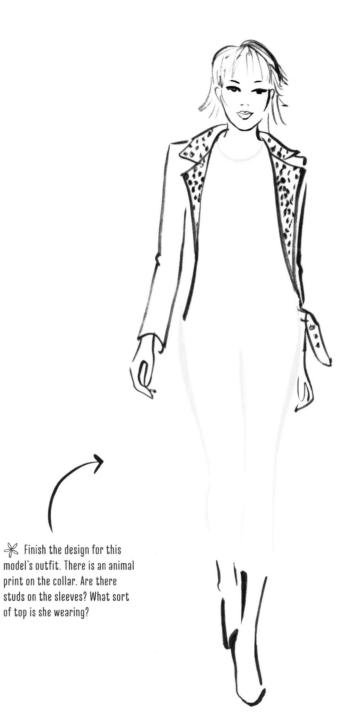

❋ Finish the design for this model's outfit. There is an animal print on the collar. Are there studs on the sleeves? What sort of top is she wearing?

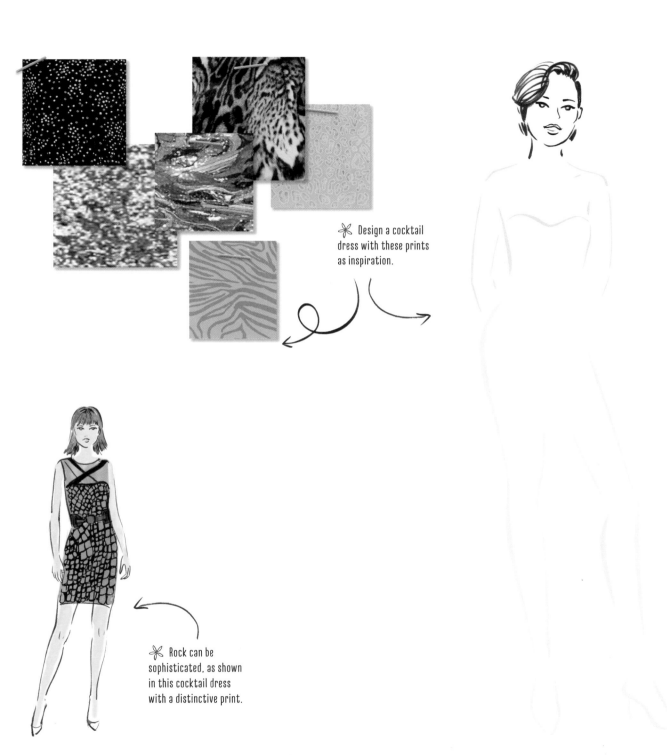

✳ Design a cocktail dress with these prints as inspiration.

✳ Rock can be sophisticated, as shown in this cocktail dress with a distinctive print.

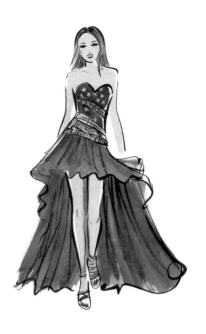

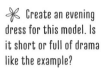

❋ Create an evening dress for this model. Is it short or full of drama like the example?

✳ Design a rock outfit for your favorite female rock star. Think about what sort of jacket she'd wear—zebra skin with studded collar detail or a menswear-inspired fitted smoking jacket for a more classic look? Mix it up by adding metallics.

PREPPY

Smart but casual, this look is the epitome of urban cool, perfect for strolling around campus and riding your bicycle. Woody Allen's Annie Hall was a preppy pioneer in her tweeds, suspenders, glasses, and striped shirts. To pull off this menswear-inspired style for yourself, choose classic pieces with a relaxed fit. Pastel colors can be added to freshen it up, and a boyfriend blazer is the perfect way to top it off.

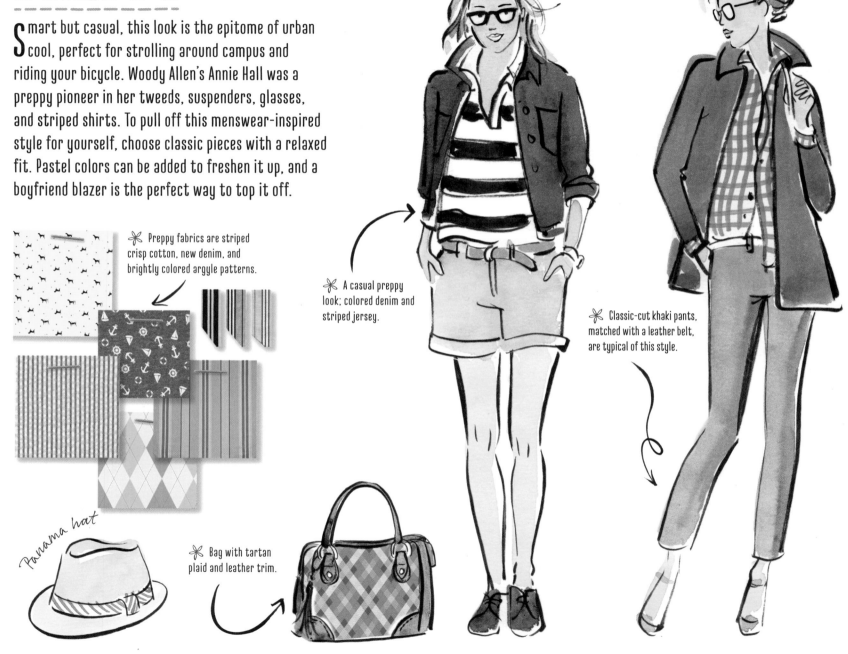

❋ Preppy fabrics are striped crisp cotton, new denim, and brightly colored argyle patterns.

❋ A casual preppy look; colored denim and striped jersey.

❋ Classic-cut khaki pants, matched with a leather belt, are typical of this style.

Panama hat

❋ Bag with tartan plaid and leather trim.

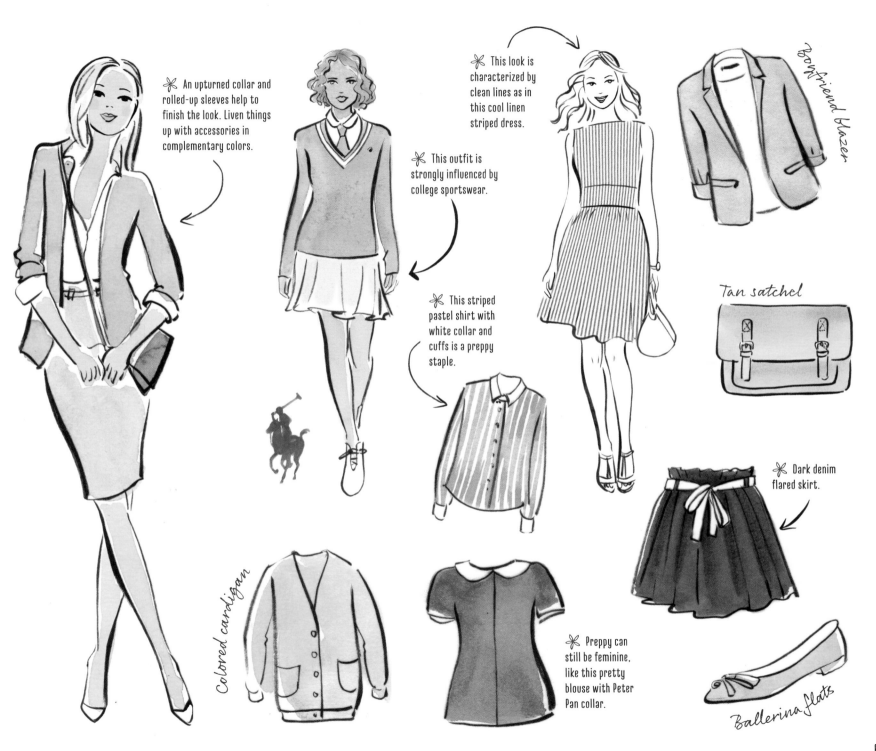

✹ An upturned collar and rolled-up sleeves help to finish the look. Liven things up with accessories in complementary colors.

✹ This outfit is strongly influenced by college sportswear.

✹ This look is characterized by clean lines as in this cool linen striped dress.

✹ This striped pastel shirt with white collar and cuffs is a preppy staple.

Boyfriend blazer

Tan satchel

✹ Dark denim flared skirt.

Colored cardigan

✹ Preppy can still be feminine, like this pretty blouse with Peter Pan collar.

Ballerina flats

61

 Finish the outfit for this model using the hat and shirt as a starting point.

✳ Now try a look for you!

✳ Blues and whites are typical for this style—think stripes.

 Finish the look. Add the details to this model's blazer and pants. Try including one of the patterns from page 60.

✳ Design a preppy outfit, thinking of your favorite sportswear styles. Try a flouncy tennis skirt or a boyfriend blazer.

 Now try a look for you!

✳ Design your own argyle patterns and use them in a garment of your own creation, like a shirt or a sweater.

GOTH

Goth is so much more than black clothing and pale skin; it's a moody clothing style that takes inspiration from the Romantic movement in eighteenth-century Europe. Key ellements of this style include flowing georgette, velvet, feathers, and brocade. The look is loose and feminine like clothing worn by Morticia Addams. Structure features heavily in a more modern Goth look: leather, metallic embellishments, and asymmetrical lines are typical, as modeled by Amy Lee of Evanescence. And structural corsets are essential regardless of whether you're keeping it modern or traditional.

✼ Goth looks take inspiration from the Romantic movement.

✼ Black lace with Gothic rose patterns, petrol blues, iridescent shades, and damask elements bring the look to life.

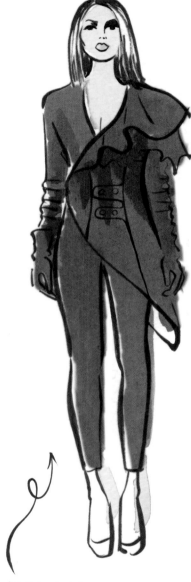

✼ Modern looks feature mixed materials like this fitted asymmetric leather jacket and pants.

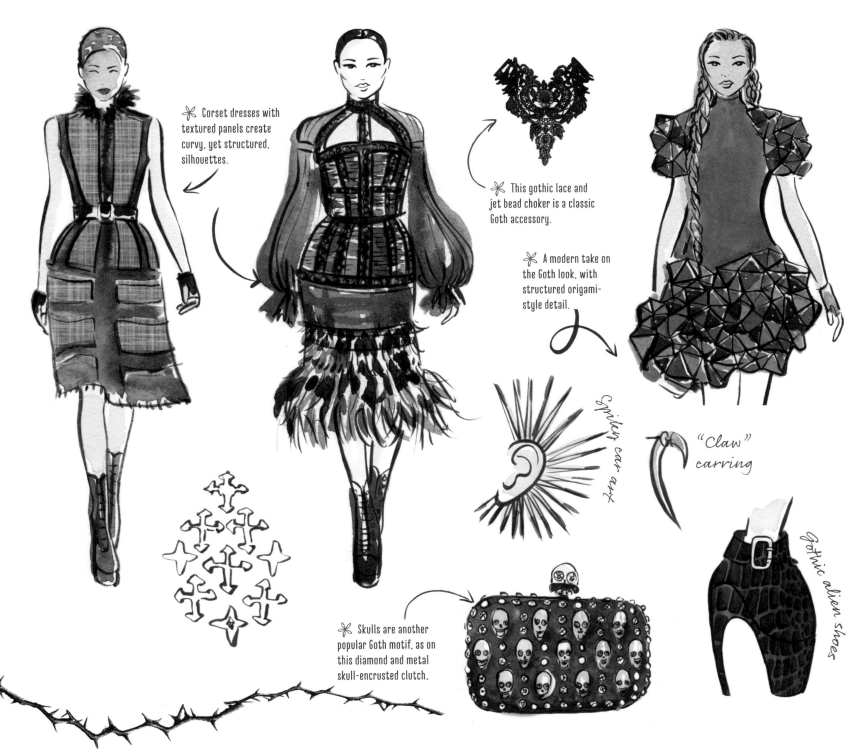

✳ Corset dresses with textured panels create curvy, yet structured, silhouettes.

✳ This gothic lace and jet bead choker is a classic Goth accessory.

✳ A modern take on the Goth look, with structured origami-style detail.

Spiky ear art

"Claw" earring

Gothic alien shoes

✳ Skulls are another popular Goth motif, as on this diamond and metal skull-encrusted clutch.

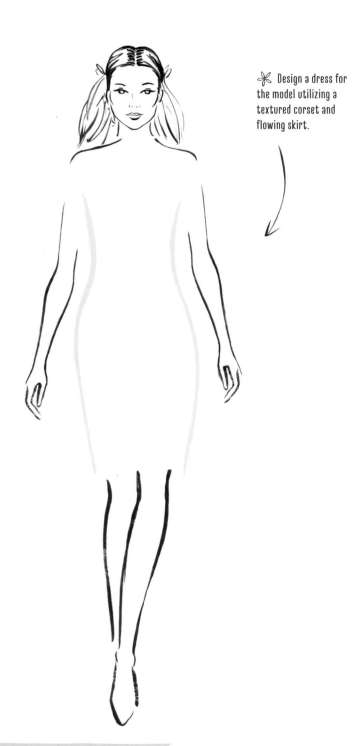

✳ Design a dress for the model utilizing a textured corset and flowing skirt.

✳ Now try a look for you!

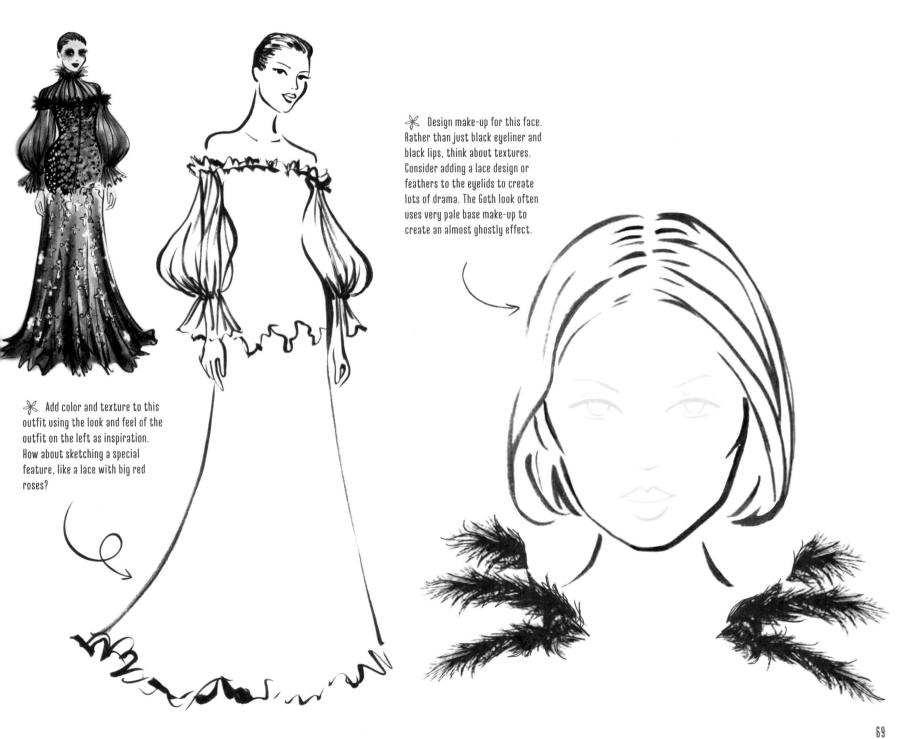

✳ Design make-up for this face. Rather than just black eyeliner and black lips, think about textures. Consider adding a lace design or feathers to the eyelids to create lots of drama. The Goth look often uses very pale base make-up to create an almost ghostly effect.

✳ Add color and texture to this outfit using the look and feel of the outfit on the left as inspiration. How about sketching a special feature, like a lace with big red roses?

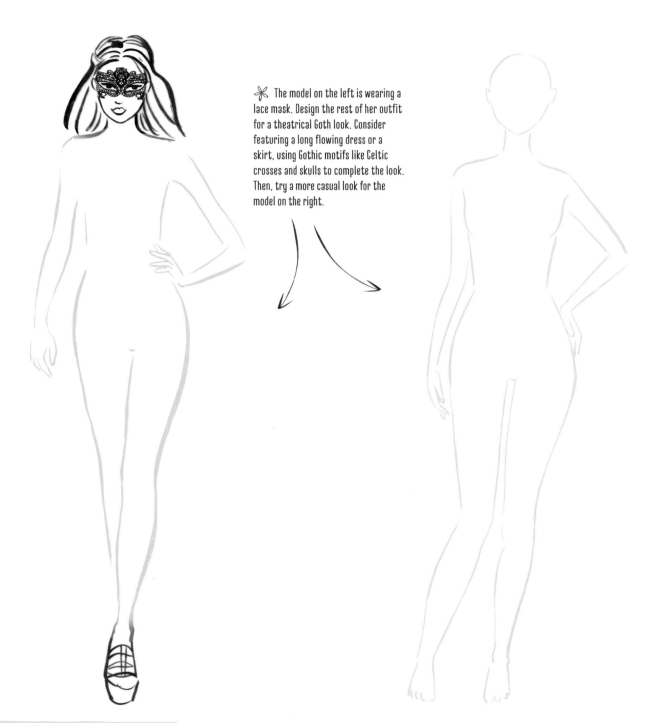

The model on the left is wearing a lace mask. Design the rest of her outfit for a theatrical Goth look. Consider featuring a long flowing dress or a skirt, using Gothic motifs like Celtic crosses and skulls to complete the look. Then, try a more casual look for the model on the right.

✳ Now create a goth look for you!

PUNK

Punk is anti-establishment DIY fashion. It started in the 1970s, when disillusioned youth rebelled against what was considered fashionable and beautiful at the time. It then took root on the streets of London and in the underground rock scene, and many a teenager and fashion designer has since used it as a reference point to shock. Punk has plenty of attitude, and this is reflected in gelled hair, heavy eyeliner, and fierce accessories (like dog collars, spiked cuffs, and safety pins) that accent the in-your-face fashions.

✳ This outfit brings the sexy to punk. Suspenders attached to wool plaid pants teamed with a vinyl bra add a quirky touch to this ensemble. Leather boots with toe cutaways complete the look.

Safety pins

✳ Patterns and textures feature heavily in punk design. This newspaper print T-shirt is taken to the next level with lots of chains, leather pants, and spiked cuffs to add to the punk look.

✳ Punk fabrics feature very strong colors (lots of black and red), animal print in new colorways, and vibrant plaids, and feature textured and unexpected materials like chainmail and vinyl.

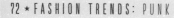

Nail-embellished bracelet

✳ Street art and propaganda posters feature heavily in punk designs. This graffiti print wool vest is teamed with blue jeans and wedged leather ankle boots for a casual look.

✳ Punk accessories are fierce, and often feature chains, spikes, and leather details.

✳ The ripped jersey T-shirt has an iconic British print, completed with plaid miniskirt and ripped tights.

Ankle-strap shoe

✳ High-heeled boots with strap and buckle details.

✳ Multiple layers of tartan in different scales and gladiator sandals add extra edge.

✳ Now draw your own asymmetric dress. You could use a punk color like bright pink or red. Consider adding some of your own embellishments, such as studs or safety pins, to give it a punky edge.

✳ Look at this dress made out of charcoal jersey and rows of safety pins. It uses asymmetric neck and hemlines and metal embellishments to create a punk style.

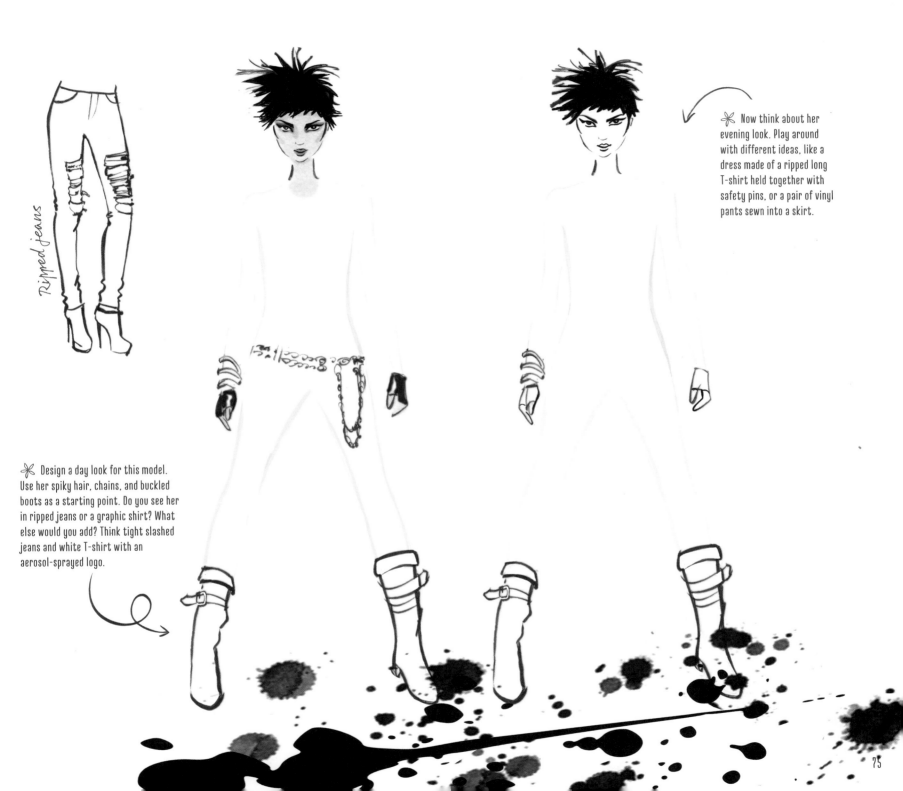

Ripped jeans

✳ Now think about her evening look. Play around with different ideas, like a dress made of a ripped long T-shirt held together with safety pins, or a pair of vinyl pants sewn into a skirt.

✳ Design a day look for this model. Use her spiky hair, chains, and buckled boots as a starting point. Do you see her in ripped jeans or a graphic shirt? What else would you add? Think tight slashed jeans and white T-shirt with an aerosol-sprayed logo.

PLAID

Plaid is used a lot in punk fashion. Here is a quick way to sketch it. Take two markers (one red, the other blue or green) and a felt-tip pen in a darker color (green, blue, or black).

1 Draw parallel vertical lines in red.

2 Now draw in horizontal lines of equal space in the same red.

3 In the other color, carefully draw between the horizontal lines.

4 Now take the finer pen and draw between the lines of the red horizontal and vertical lines.

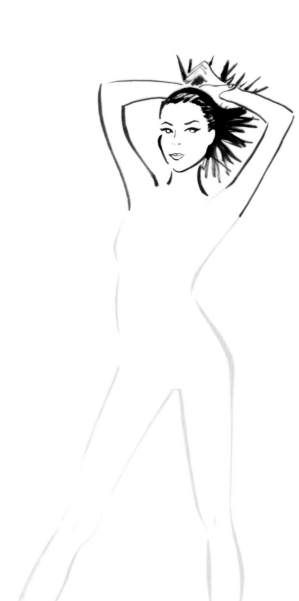

✳ Draw a plaid outfit on this
It could be a catsuit, or bodice a
skirt, or multicolored splattered
ripped ball gown—whatever you

❋ Now create a punk look for you!

DECADES IN FASHION
THE 1920s

The 1920s were a time of change and new-found freedom for women. "Flapper" girls cast aside the restricting corsets of the early 1900s in favor of the slip dress, in which they could move with ease and dance with wild abandon to the latest jazz records. Waistlines were low, and layers and detailing were most definitely in, with tiers, panels, and tassels that accentuated the wearer's movements, and glimmering beads that reflected the dazzling party lights. In this period, daywear became sleeker and more suitable for "gadding about," featuring shorter hemlines and flirty little box pleats below the dropped waists of dresses.

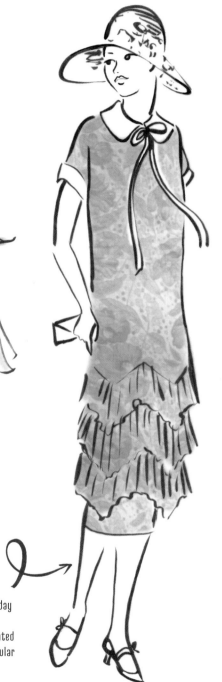

✳ This tennis dress, with its dropped waist and box pleats, was typical of the 1920s silhouette.

✳ The art-deco period heavily influenced fabric design, with geometric patterns, rich metallics, and heavy line detailing becoming prevalent, particularly for evening wear. Flowers and polka dots were popular for daywear. Popular fabrics included chiffon, cotton, wool, silk, and rayon.

Saddle shoes

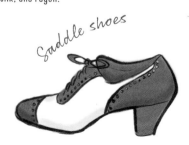

✳ This mid-calf day dress is made from layered chiffon printed with flowers, a popular motif of the era.

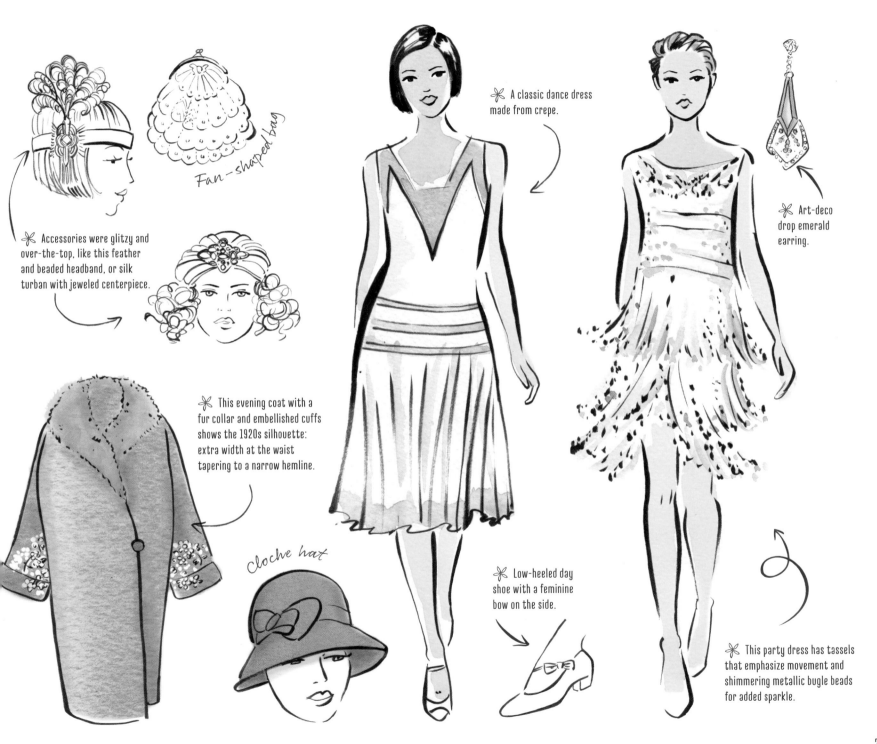

✳ A classic dance dress made from crepe.

Fan-shaped bag

✳ Accessories were glitzy and over-the-top, like this feather and beaded headband, or silk turban with jeweled centerpiece.

✳ Art-deco drop emerald earring.

✳ This evening coat with a fur collar and embellished cuffs shows the 1920s silhouette: extra width at the waist tapering to a narrow hemline.

Cloche hat

✳ Low-heeled day shoe with a feminine bow on the side.

✳ This party dress has tassels that emphasize movement and shimmering metallic bugle beads for added sparkle.

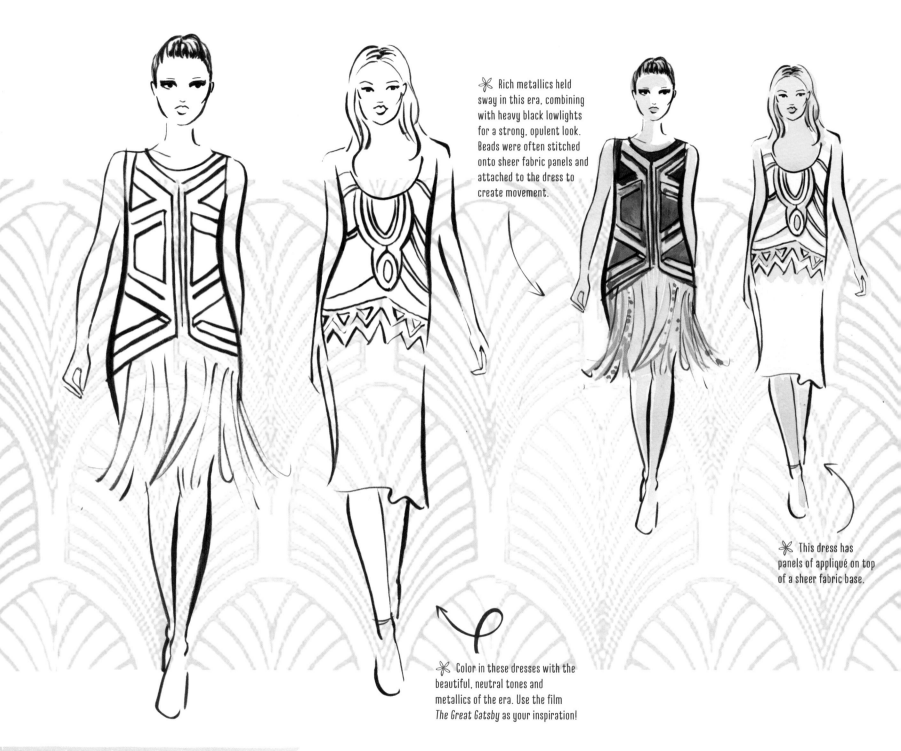

✳ Rich metallics held sway in this era, combining with heavy black lowlights for a strong, opulent look. Beads were often stitched onto sheer fabric panels and attached to the dress to create movement.

✳ This dress has panels of appliqué on top of a sheer fabric base.

✳ Color in these dresses with the beautiful, neutral tones and metallics of the era. Use the film *The Great Gatsby* as your inspiration!

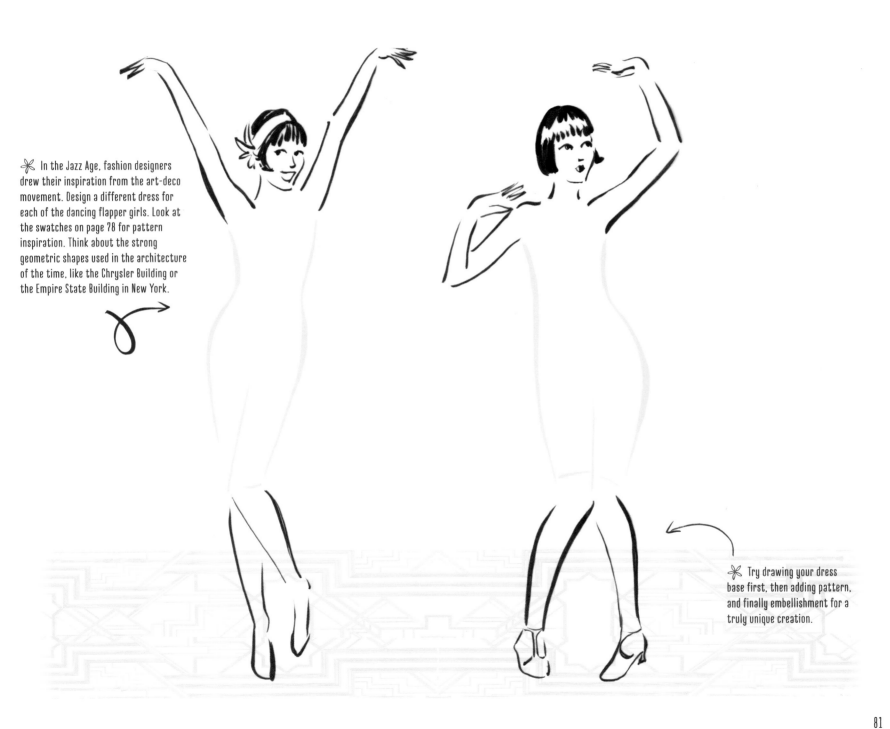

✳ In the Jazz Age, fashion designers drew their inspiration from the art-deco movement. Design a different dress for each of the dancing flapper girls. Look at the swatches on page 78 for pattern inspiration. Think about the strong geometric shapes used in the architecture of the time, like the Chrysler Building or the Empire State Building in New York.

✳ Try drawing your dress base first, then adding pattern, and finally embellishment for a truly unique creation.

✽ On the tennis dress on page 78, the pleats start from the dropped waistline and finish below the knee. Try drawing some pleated looks of your own.

✽ Now try drawing a 1920s-inspired outfit for yourself!

 Performers like Rihanna have been inspired by the sleek look of this era: the headgear, the earrings, the fur stole, and the dresses. Take one of the 1920s designs from the previous pages and mix it up with a modern vibe. Try starting with a traditional design and adding modern elements one at a time—maybe you can change a hemline, add a different collar, or use a contemporary pattern.

THE 1930s

In the 1930s, sirens of the silver screen like Greta Garbo oozed glamour in flowing silk gowns that showed off every lean curve and willowy, tall figures with small busts and narrow hips were considered the ideal. Swing dance required lots of movement, so dresses were flowing and fluid. Women wore their hair in soft waves, or long and glossy. For the first time, women wore menswear-inspired styles; shirt dresses were popular for daytime, and Marlene Dietrich caused a scandal when first seen in pants.

✳ Pretty floral prints abounded with lots of green and with punches of red. Fabrics included chiffon, crepe de chine, silk, and satin.

Heeled brogue shoes

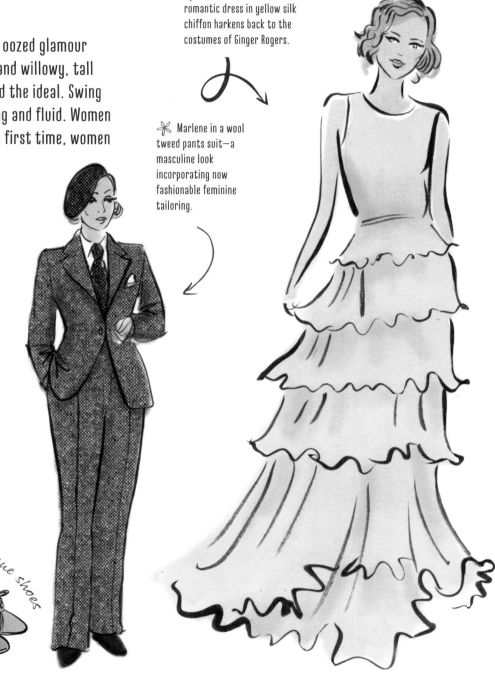

✳ This very feminine and romantic dress in yellow silk chiffon harkens back to the costumes of Ginger Rogers.

✳ Marlene in a wool tweed pants suit—a masculine look incorporating now fashionable feminine tailoring.

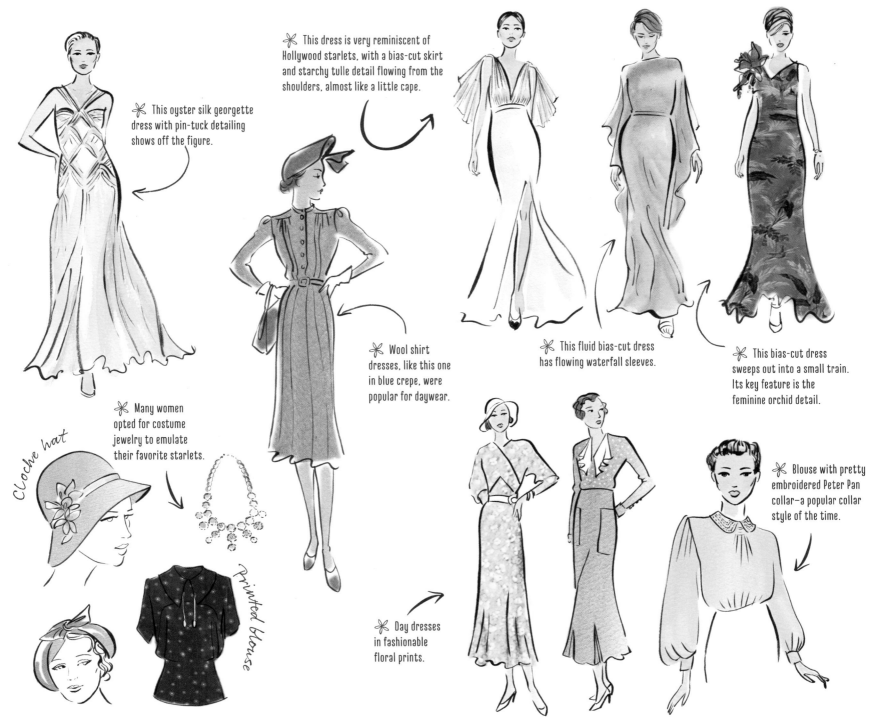

✳ This oyster silk georgette dress with pin-tuck detailing shows off the figure.

✳ This dress is very reminiscent of Hollywood starlets, with a bias-cut skirt and starchy tulle detail flowing from the shoulders, almost like a little cape.

✳ Wool shirt dresses, like this one in blue crepe, were popular for daywear.

✳ This fluid bias-cut dress has flowing waterfall sleeves.

✳ This bias-cut dress sweeps out into a small train. Its key feature is the feminine orchid detail.

✳ Many women opted for costume jewelry to emulate their favorite starlets.

Cloche hat

Printed blouse

✳ Day dresses in fashionable floral prints.

✳ Blouse with pretty embroidered Peter Pan collar—a popular collar style of the time.

✳ Add the details to finish off these daytime outfits. Thnk about adding different collars or sleeves to set them apart. What color or patterns will you use?

 Create your own film star dress design. Think about bias-cut dresses and how they cling to the body. Where is it best to cling and where (for practical reasons, like walking) is it best to have more fabric? For more information about how to sketch bias-cut fabric, see page 23.

 How are you going to add more fabric? Is it the way the fabric drapes or it there a seam where a panel of extra fabric can be added? Some fitted dresses have a seam above the knee so extra fullness can be added. These seams are often diagonal, rather than horizontal. Try to think where you would place these asymmetric seams.

✳ Let's take another look from the 1930s: the shirtwaist dress, a pattern that has cropped up again and again over the decades. Try and alter the look to fit a modern wardrobe—think about using longer sleeves, a belt, and change the length to freshen up the look.

✳ Now try your own look!

✳ The 1930s were all about glamour and sleek design with a couple of details for interest. What elements would be good in your wardrobe? For instance, a bias-cut crepe silk skirt would look great under a crocheted woolly sweater.

THE 1940s

The fashion of the 1940s is split into two halves. In the early half of the decade it was all about feminine, small floral prints in subtle shades and the military utilitarian look, with trench coats and khaki. Two key looks from this era have an enduring quality that is referenced again and again: cotton lawn dresses with pastel sprig motifs for the summer, and square-shouldered woolen suits for the winter (with influence from men's military uniforms). The latter half of the decade, the postwar years, saw a return to more decadent, glamorous designs, with small waists and full-circle skirts, referred to as the "New Look."

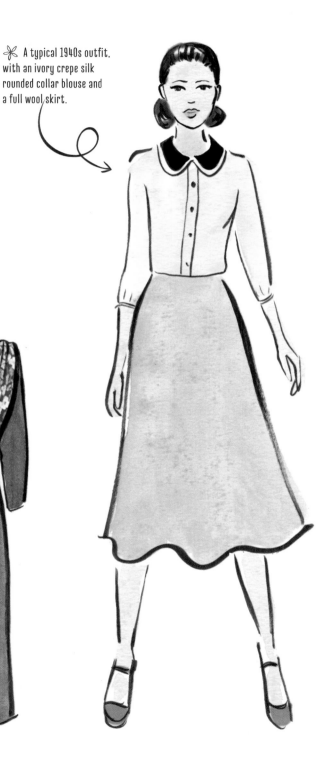

✳ A typical 1940s outfit, with an ivory crepe silk rounded collar blouse and a full wool skirt.

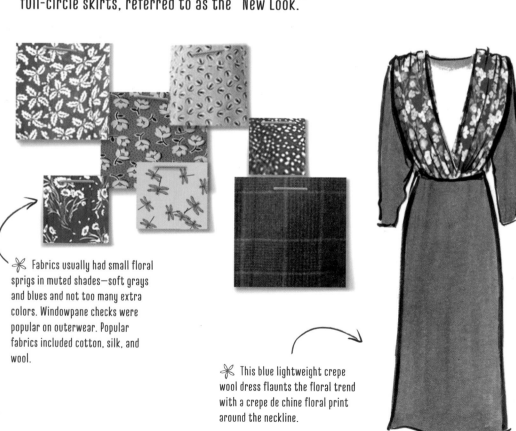

✳ Fabrics usually had small floral sprigs in muted shades—soft grays and blues and not too many extra colors. Windowpane checks were popular on outerwear. Popular fabrics included cotton, silk, and wool.

✳ This blue lightweight crepe wool dress flaunts the floral trend with a crepe de chine floral print around the neckline.

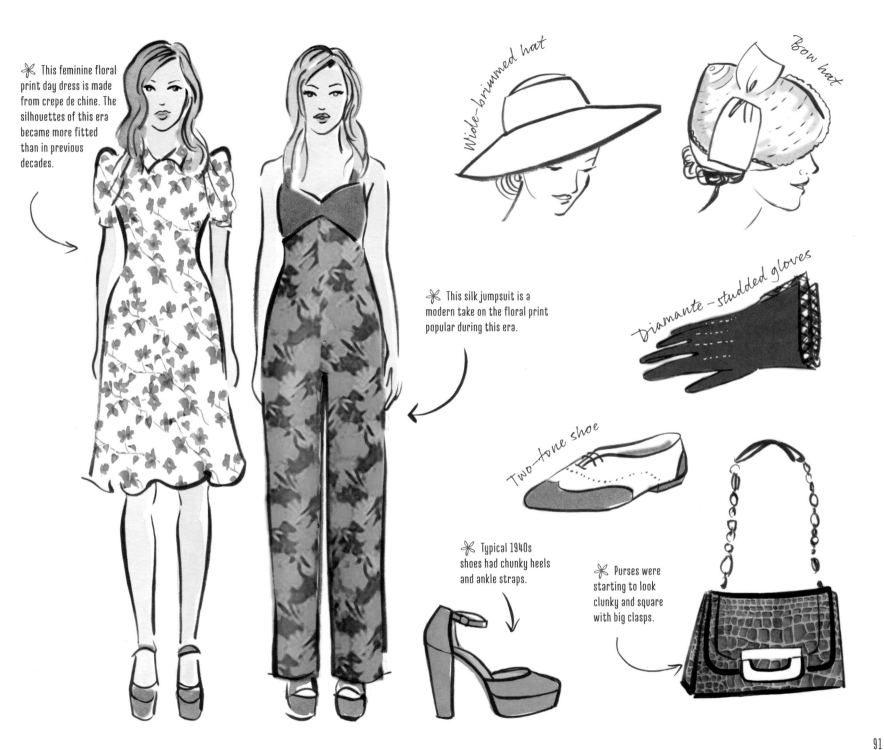

✳ This feminine floral print day dress is made from crepe de chine. The silhouettes of this era became more fitted than in previous decades.

Wide-brimmed hat

Bow hat

✳ This silk jumpsuit is a modern take on the floral print popular during this era.

Diamante-studded gloves

Two-tone shoe

✳ Typical 1940s shoes had chunky heels and ankle straps.

✳ Purses were starting to look clunky and square with big clasps.

✳ Create an outfit combining the feminine floral look with the more utilitarian look (consider adding a floral pattern to a military wool coat, for instance). Don't forget to add accessories like hats or bags.

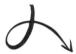

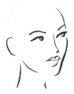

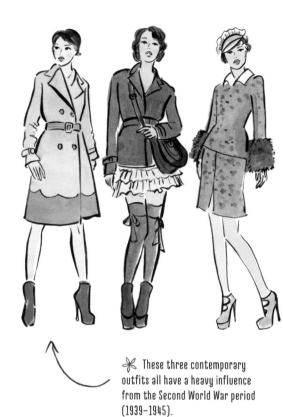

✳ These three contemporary outfits all have a heavy influence from the Second World War period (1939–1945).

 Now create a 1940s-inspired suit look for you!

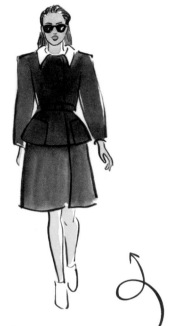

✳ This is a modern take on 1940s suit, with its full skirt and nipped-in waist.

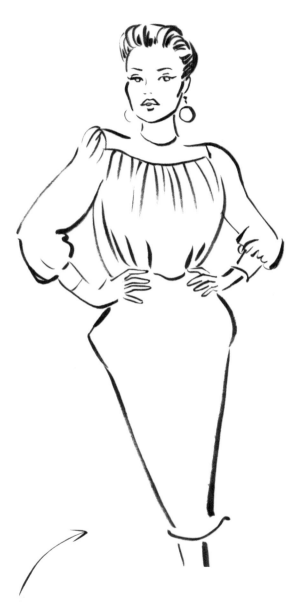

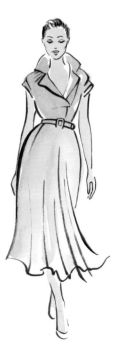

✳ Ultra feminine belted day dress in lilac crepe rayon.

✳ Complete this day look by adding pattern. Mix up the typical floral sprigs by using over-scaled print rather than the tiny patterns of the 1940s. Add some shocking colors to prevent it from looking too retro and soft and to give it a modern feel.

✳ Design a modern-day work suit using the key elements of the early 1940s: big collars, small, nipped-in waist, and exaggerated hips. For help with collars and jackets, see pages 33 and 38–39.

THE 1950s

In this very feminine era, Marilyn Monroe was thought of as the ideal woman, with her curves and small waist. Skirts were either full or pencil, emphasizing the waist and hip curve. The full circle skirt with big flower print epitomizes the decade. Blouses were fitted, to show off a full bust, with three-quarter-length sleeves and Peter Pan collars. It all created a very stylized version of femininity: think of the typical image of a woman in full floral dress, with nipped-in waist, frilly gingham apron, full make-up, and bouffant hair.

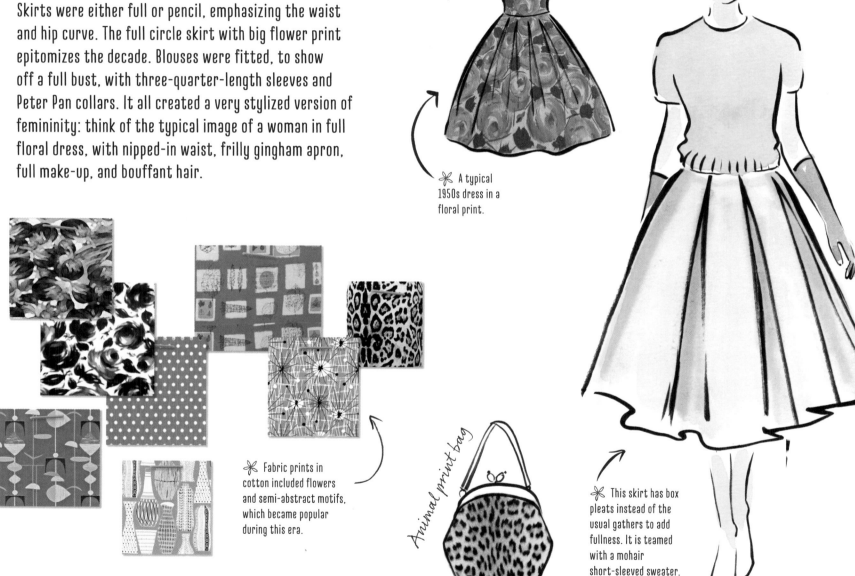

✳ A typical 1950s dress in a floral print.

✳ Fabric prints in cotton included flowers and semi-abstract motifs, which became popular during this era.

Animal print bag

✳ This skirt has box pleats instead of the usual gathers to add fullness. It is teamed with a mohair short-sleeved sweater.

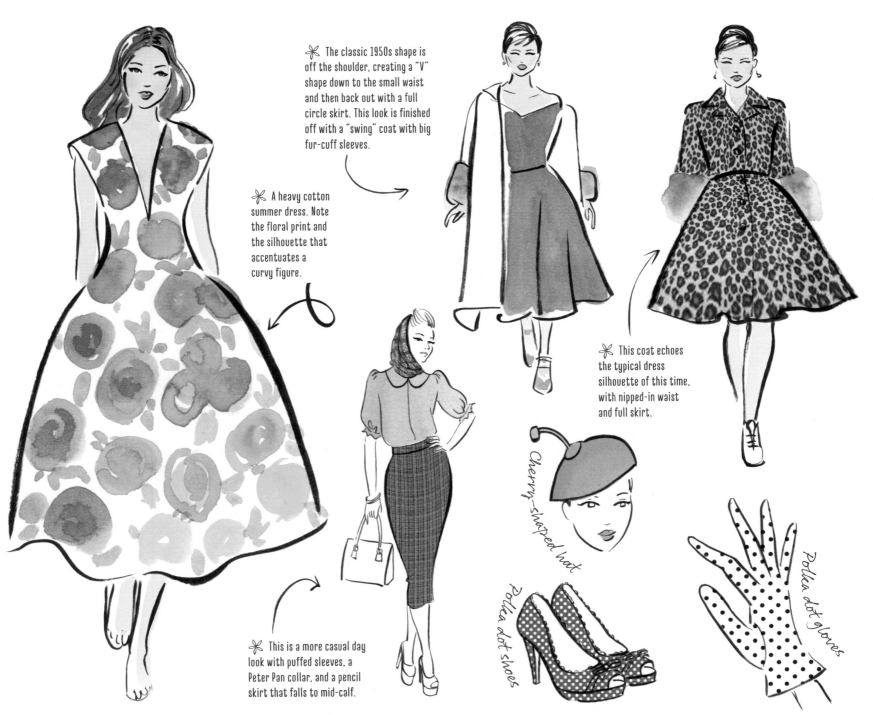

✳ The classic 1950s shape is off the shoulder, creating a "V" shape down to the small waist and then back out with a full circle skirt. This look is finished off with a "swing" coat with big fur-cuff sleeves.

✳ A heavy cotton summer dress. Note the floral print and the silhouette that accentuates a curvy figure.

✳ This coat echoes the typical dress silhouette of this time, with nipped-in waist and full skirt.

✳ This is a more casual day look with puffed sleeves, a Peter Pan collar, and a pencil skirt that falls to mid-calf.

Cherry-shaped hat

Polka dot shoes

Polka dot gloves

97

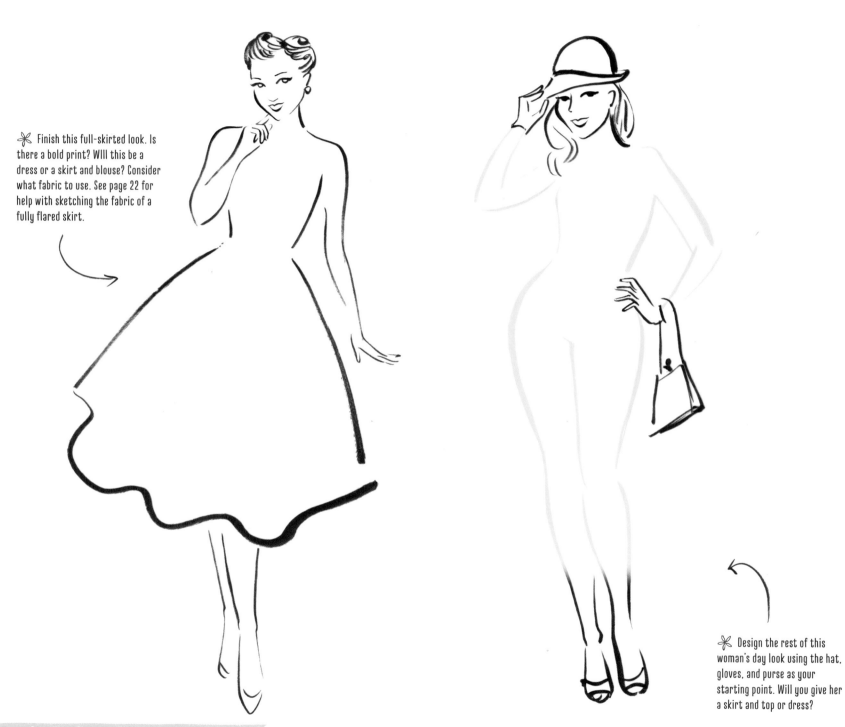

✳ Finish this full-skirted look. Is there a bold print? WIll this be a dress or a skirt and blouse? Consider what fabric to use. See page 22 for help with sketching the fabric of a fully flared skirt.

✳ Design the rest of this woman's day look using the hat, gloves, and purse as your starting point. Will you give her a skirt and top or dress?

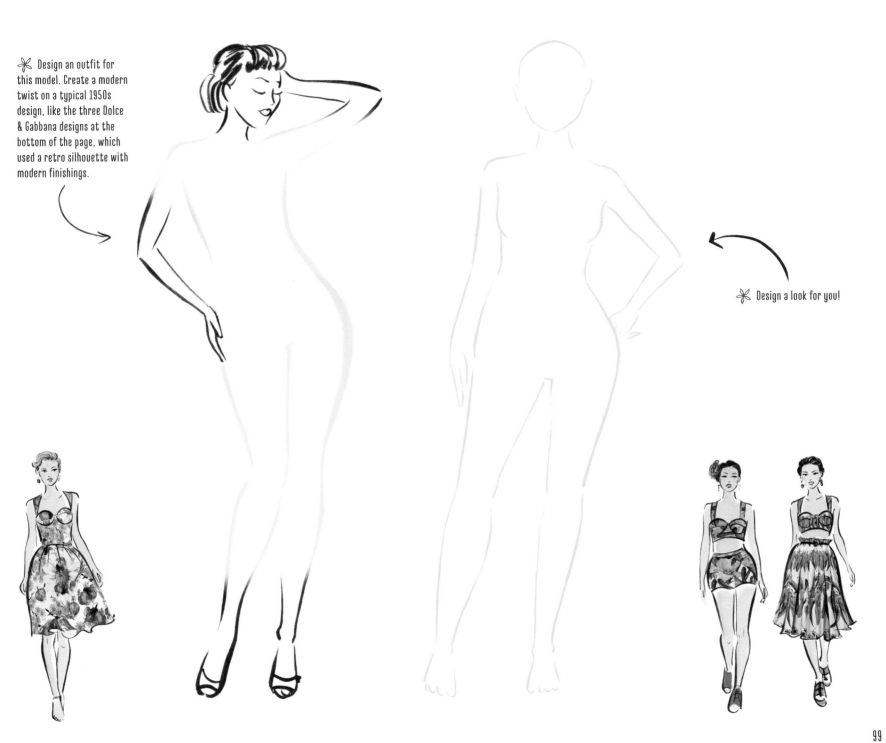

✳ Design an outfit for this model. Create a modern twist on a typical 1950s design, like the three Dolce & Gabbana designs at the bottom of the page, which used a retro silhouette with modern finishings.

✳ Design a look for you!

99

✳ Now try and design two different 1950s-inspired outfits to flatter the two distinct figures. Use the guidelines on pages 14–16 if you can't remember which shapes flatten which body types.

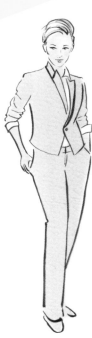

 You've seen how the 1950s was all about creating an idealized version of femininity, celebrating curves on the bust and hips. Now take a modern celebrity or actress who has a unisex or more androgynous look (think Tilda Swindon) and design a more feminine look with a full skirt that changes the shape of the figure. Use the rectangle body shape (see page 16) as your base template.

THE 1960s

The 1960s was a time of great social change and the fashion was equally revolutionary. Youth rebelled, wanting to push away from conservative 1950s norms. The sexual revolution, the hippy movement, and the space race all influenced fashion and pushed it to extremes. Mary Quant and Ossie Clark designed short shift dresses that showed off the legs, and were worn with colored tights and heeled boots. Other designers took their inspiration from art, using bold prints in the style of the artist Piet Mondrian. Young fashion photographers like David Bailey and Richard Avedon pushed boundaries, using young and natural models like Twiggy and Jean Shrimpton.

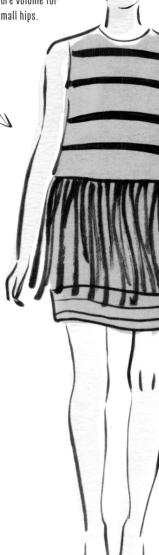

✳ This heavy silk dress with leather tassels gives off a sixties go-go dancer feel. This fringe technique is great for creating more volume for a model with small hips.

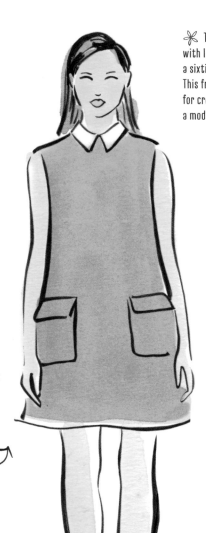

✳ A 1960s-inspired shift dress in wool crepe. Notice the collar and oversized patch pocket details.

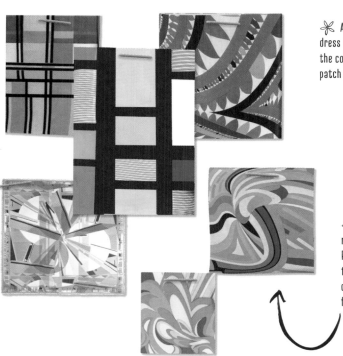

✳ A range of patterns, old and new, by the Italian designer Emilio Pucci. They capture the spirit of the 1960s with their bright, almost clashing colors and swirls. Popular fabrics included silks and silk crepe.

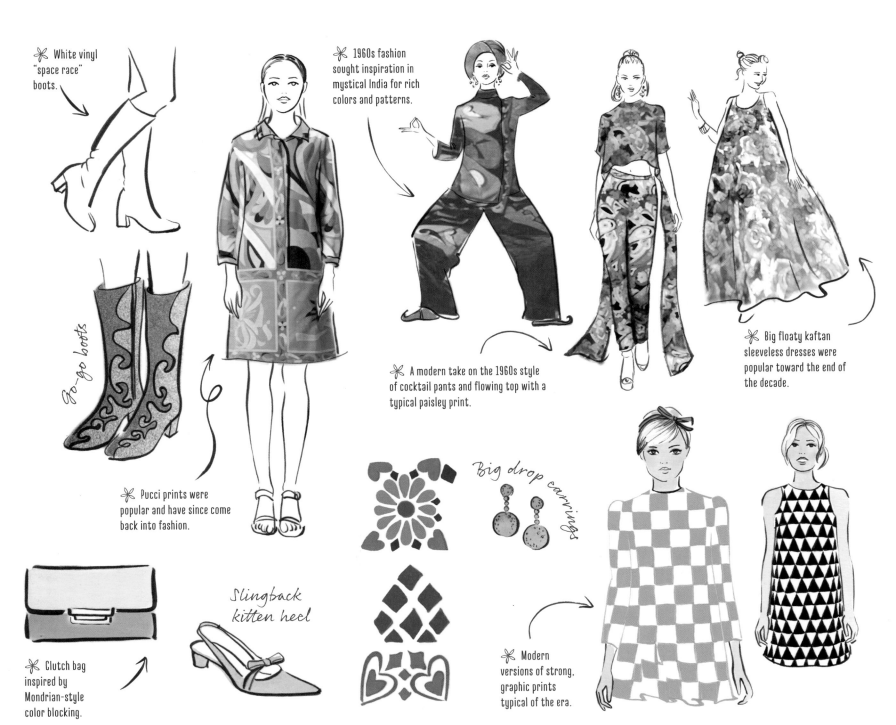

✳ White vinyl "space race" boots.

✳ 1960s fashion sought inspiration in mystical India for rich colors and patterns.

✳ Big floaty kaftan sleeveless dresses were popular toward the end of the decade.

Go-go boots

✳ A modern take on the 1960s style of cocktail pants and flowing top with a typical paisley print.

✳ Pucci prints were popular and have since come back into fashion.

Big drop earrings

Slingback kitten heel

✳ Clutch bag inspired by Mondrian-style color blocking.

✳ Modern versions of strong, graphic prints typical of the era.

103

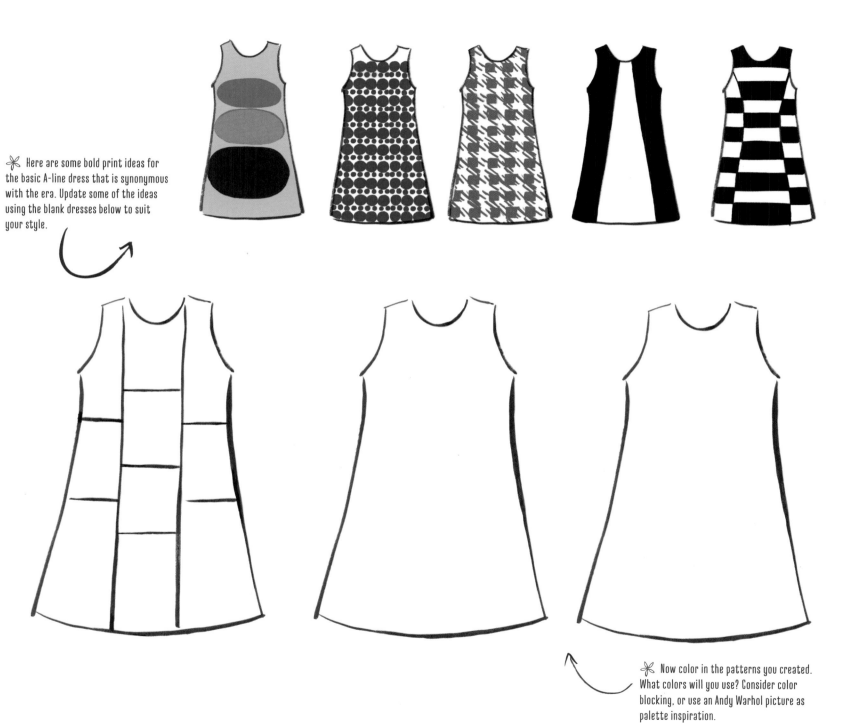

✳ Here are some bold print ideas for the basic A-line dress that is synonymous with the era. Update some of the ideas using the blank dresses below to suit your style.

✳ Now color in the patterns you created. What colors will you use? Consider color blocking, or use an Andy Warhol picture as palette inspiration.

 Create an outfit with your own Mondrian-inspired print. Think about the colors you will use. See the color wheel on pages 24–25 for more ideas about which colors work well together.

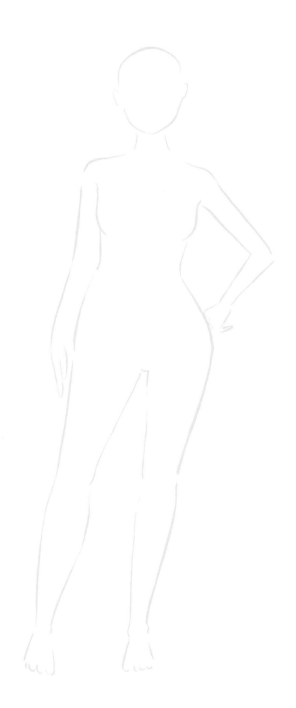

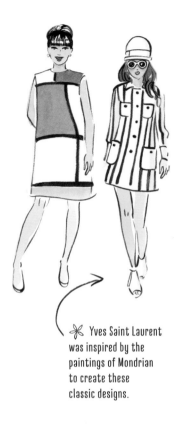

✳ Yves Saint Laurent was inspired by the paintings of Mondrian to create these classic designs.

 Pucci's kaleidoscopic fabric patterns are synonymous with the 1960s. Use them as your inspiration to design an outfit. Try to incorporate the swirling elements of the pattern into your garment design. A floaty hippie-style dress would work perfectly.

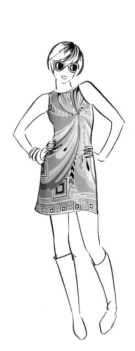

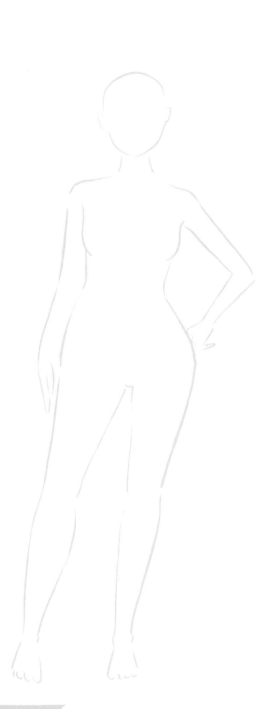

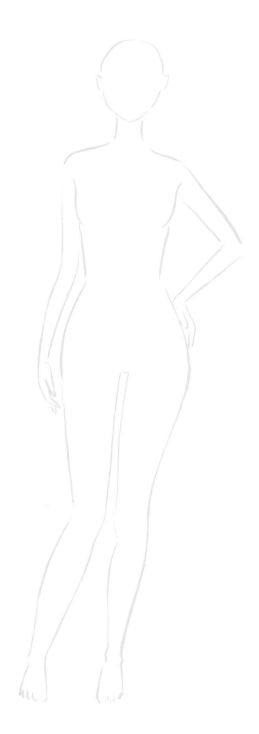

✳ Now design a 1960s day look for you!

THE 1970s

It's the 1970s: think Donna Summer disco, floppy bows, Farrah Fawcett hair, nylon, high-waisted flares, bohemian floaty dresses, kaftans, oriental influences, and bright, busy prints. It was a time for fun and confidence, when the young started exploring the world and taking on other cultural influences with embroidery, fringe, patterns, and color. Pants went from straight-legged to bell bottoms. Maxi dresses, denim, and suede were all popular choices for daywear.

✳ Prints included clashing vibrant florals in pinks and oranges. Browns and yellows were also popular. Fabrics included nylon, velvet, cheesecloth, and polyester.

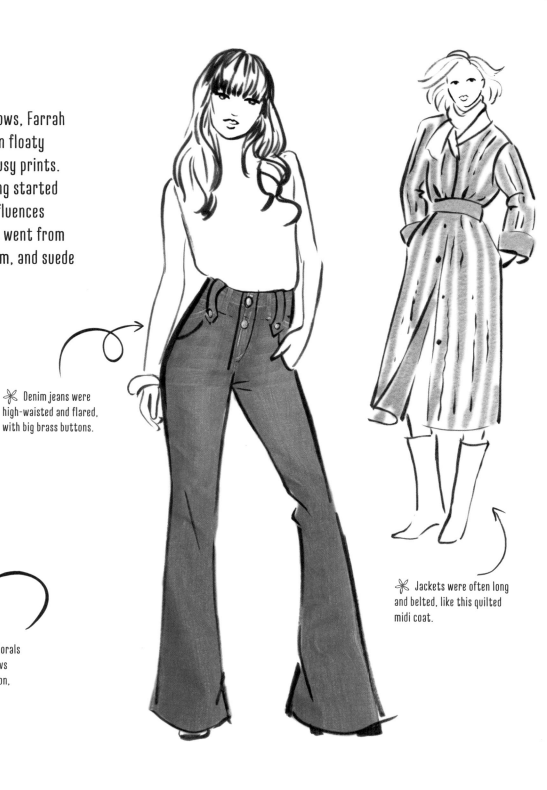

✳ Denim jeans were high-waisted and flared, with big brass buttons.

✳ Jackets were often long and belted, like this quilted midi coat.

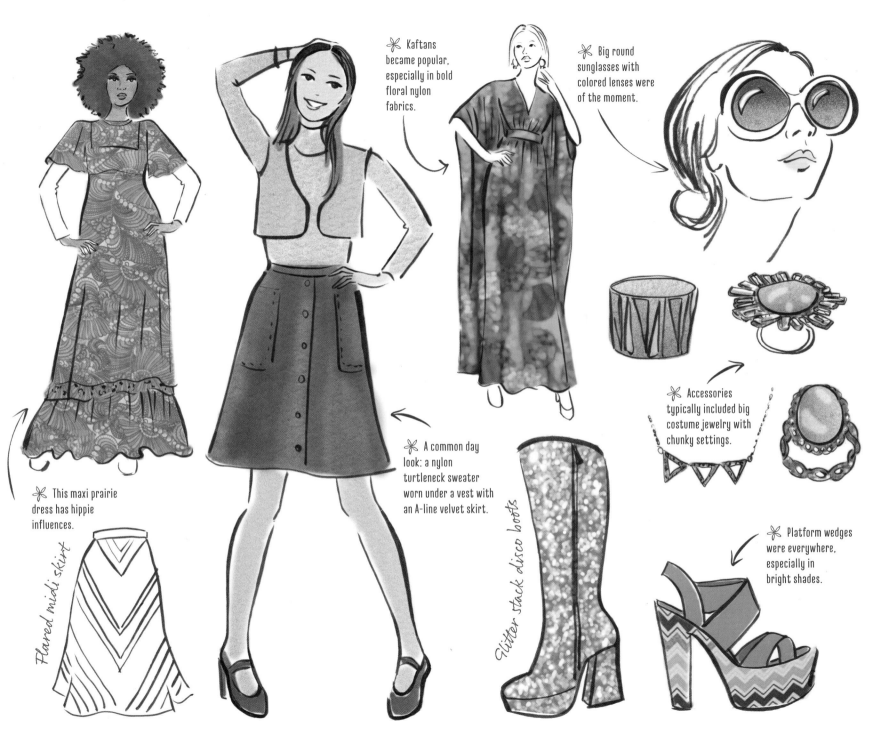

✳ Kaftans became popular, especially in bold floral nylon fabrics.

✳ Big round sunglasses with colored lenses were of the moment.

✳ This maxi prairie dress has hippie influences.

Flared midi skirt

✳ A common day look: a nylon turtleneck sweater worn under a vest with an A-line velvet skirt.

✳ Accessories typically included big costume jewelry with chunky settings.

Glitter stack disco boots

✳ Platform wedges were everywhere, especially in bright shades.

✷ This model has two trends of the time: Farrah hair and platform shoes.

✷ Now design a look for you!

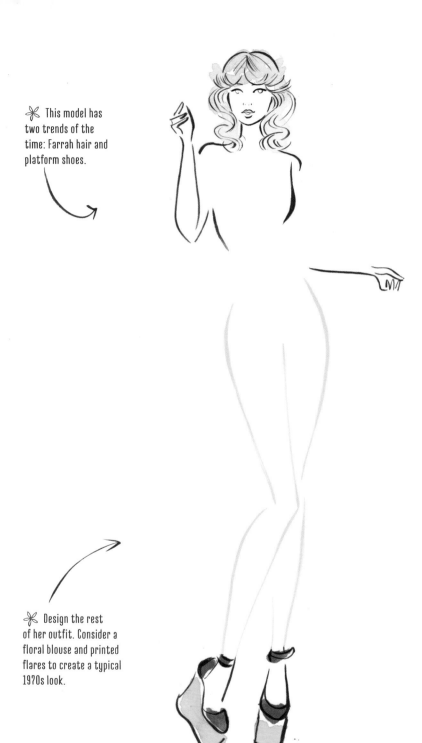

✷ Design the rest of her outfit. Consider a floral blouse and printed flares to create a typical 1970s look.

 Design a modern take on a 1970s day look, starting with this oversized hat, purple flower, and crimped hair. Why not try a floaty maxi dress style? Remember to play with colors and prints in the style of the era.

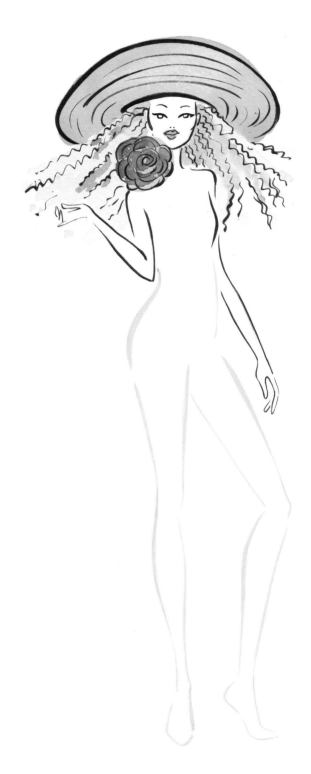

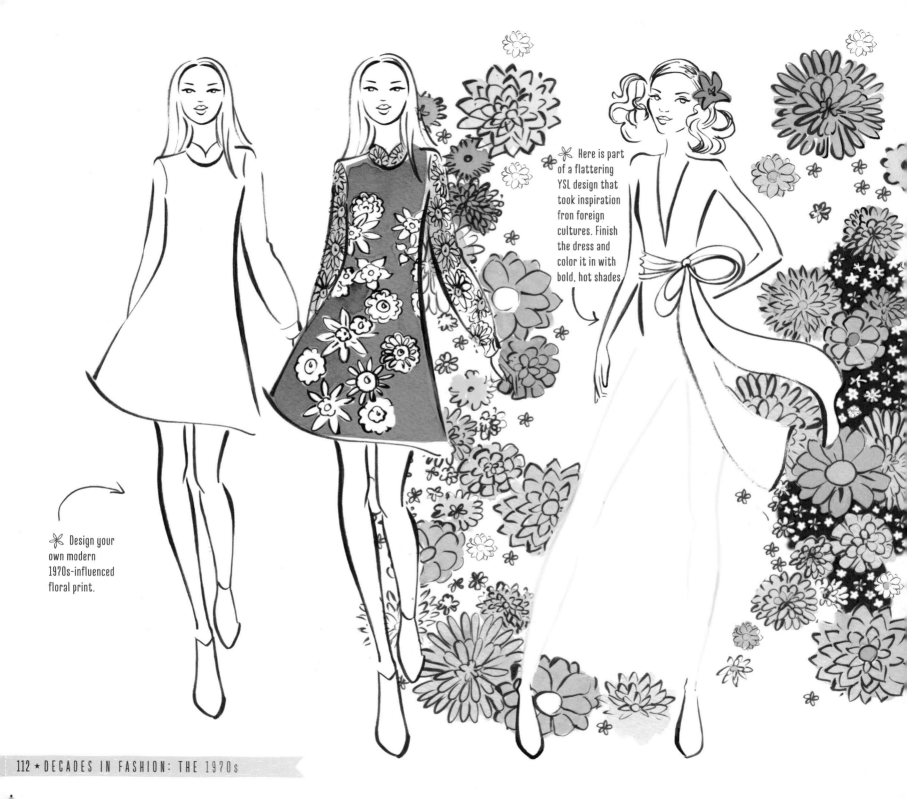

✿ Design your
own modern
1970s-influenced
floral print.

✿ Here is part
of a flattering
YSL design that
took inspiration
fron foreign
cultures. Finish
the dress and
color it in with
bold, hot shades.

❋ Create and sketch your own
1970s-inspired day look. Are you more
casual, with bell bottoms and a T-shirt?
Or do you have more of a laid-back hippie
vibe, with a boldly printed bohemian maxi?

THE 1980s

In the 1980s, fashion was all about materialism and bright, vivid colors. Women power-dressed in shoulder-padded suits, and expressed an image of wealth with sparkly costume jewelry such as large faux-gold earrings and pearl necklaces. Hairstyles were typically big, curly, and piled high—think *Dynasty* and *Dallas*—and make-up was bright and heavy, with light-colored lips, thick eyelashes, and heavy blush under the cheekbone. Pop star Madonna popularized the "street urchin" look, with short net skirts worn over leggings, necklaces, rubber bracelets, fishnet gloves, hairbows, long layered strings of beads and crosses, bleached untidy hair with dark roots, headbands, and lace ribbons. Another look came from the aerobics craze: Lycra, leotards, leg warmers, neon, and sweatshirts with large neck openings became hugely popular.

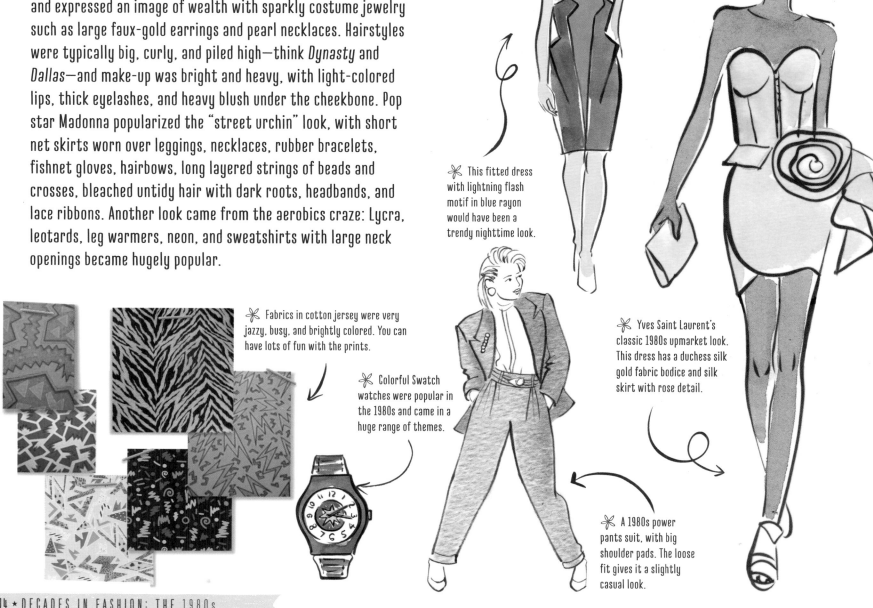

✳ This fitted dress with lightning flash motif in blue rayon would have been a trendy nighttime look.

✳ Fabrics in cotton jersey were very jazzy, busy, and brightly colored. You can have lots of fun with the prints.

✳ Colorful Swatch watches were popular in the 1980s and came in a huge range of themes.

✳ Yves Saint Laurent's classic 1980s upmarket look. This dress has a duchess silk gold fabric bodice and silk skirt with rose detail.

✳ A 1980s power pants suit, with big shoulder pads. The loose fit gives it a slightly casual look.

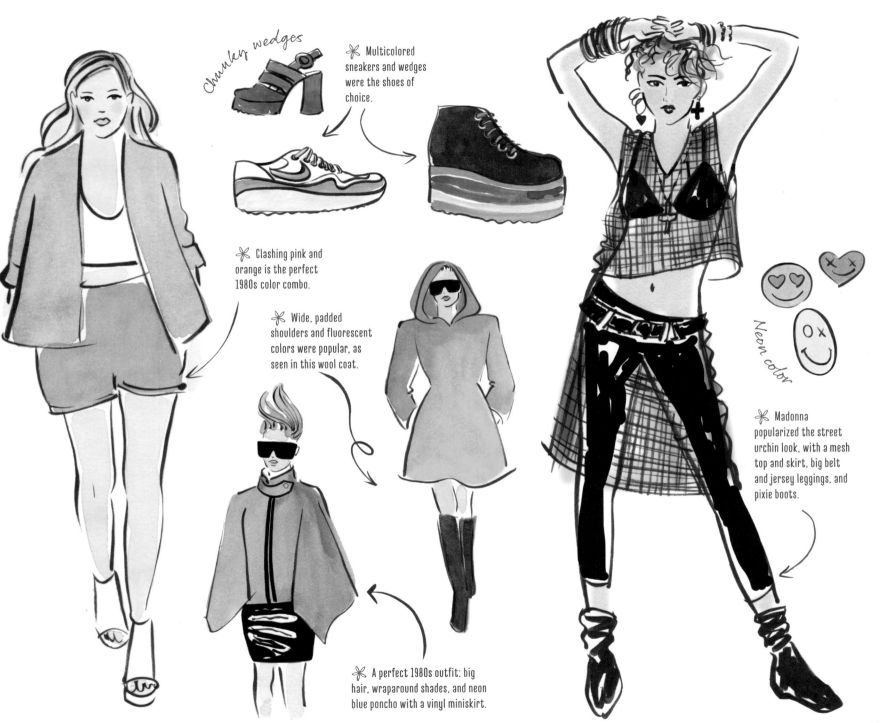

Chunky wedges

✳ Multicolored sneakers and wedges were the shoes of choice.

✳ Clashing pink and orange is the perfect 1980s color combo.

✳ Wide, padded shoulders and fluorescent colors were popular, as seen in this wool coat.

Neon color

✳ Madonna popularized the street urchin look, with a mesh top and skirt, big belt and jersey leggings, and pixie boots.

✳ A perfect 1980s outfit: big hair, wraparound shades, and neon blue poncho with a vinyl miniskirt.

✷ Design and color in the model's aerobic look. Remember, the more over the top, the better!

✷ Now switch it up! Add a logo or pattern to her leggings to keep the look fresh.

 Nighttime looks from the 1980s were short, flouncy, and bright. Design your own party dress using the dresses at right as inspiration.

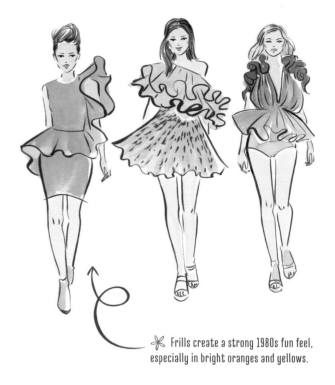

✳ Frills create a strong 1980s fun feel, especially in bright oranges and yellows.

✳ Use frills to draw focus to different parts of the body.

117

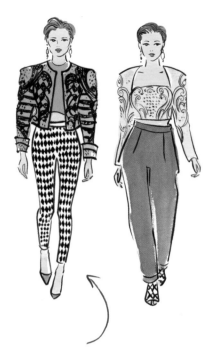

✳ Versace's bright-colored outfits, with big shoulders and decorative baroque detail, create a strong silhouette.

✳ Design another outfit from the same collection as these two Versace designs. Try to create strong silhouettes with shoulder pads and pleated seams.

✳ Now create a 1980s-inspired design for yourself! Think about your favorite colors, patterns, and silhouettes.

✳ The 1980s were strongly influenced by the 1940s power-dressing look (see page 93). Take elements from the two decades and design and sketch a modern power-dressing look.

THE 1990s

The 1990s were the more minimalist answer to the 1980s. Rather than the glam, hyper-stylized look of the 1980s, a more unisex casual chic look gained appeal, with stonewash jeans, spaghetti strap crop tops, sweatpants, and athletic clothing coming to the forefront. Denim's popularity was at an all-time high. Supermodels dominated the decade, with Cindy Crawford, Naomi Campbell, and Kate Moss leading the crowd. Grunge fashion broke into the mainstream from the music scene, with flannel shirts, ripped jeans, combat boots, band T-shirts, oversized knit sweaters, long and droopy skirts, ripped tights, and Birkenstocks.

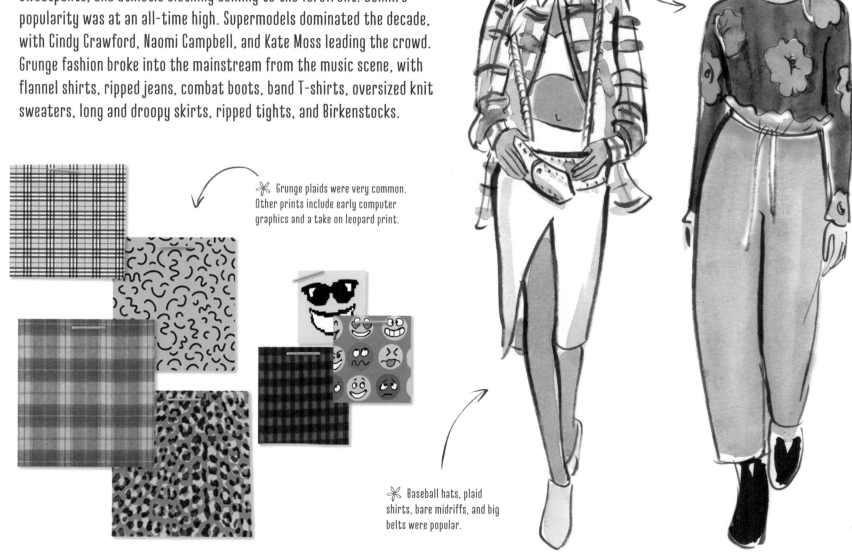

✳ The fit of the clothing became more unisex, like this outfit with a big poppy print on a transparent black sweater and baggy jeans.

✳ Grunge plaids were very common. Other prints include early computer graphics and a take on leopard print.

✳ Baseball hats, plaid shirts, bare midriffs, and big belts were popular.

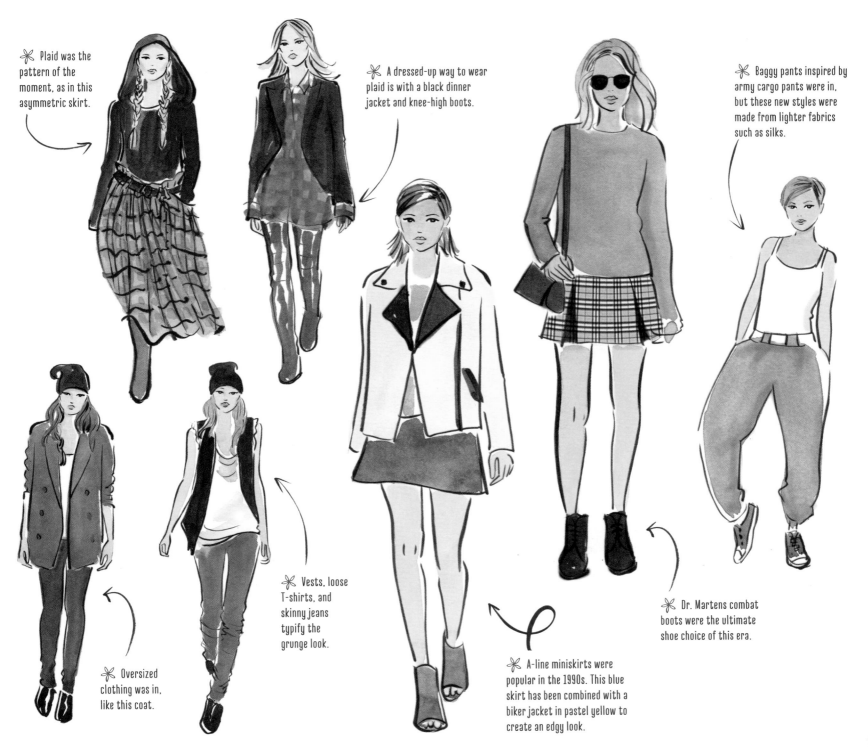

✳ Plaid was the pattern of the moment, as in this asymmetric skirt.

✳ A dressed-up way to wear plaid is with a black dinner jacket and knee-high boots.

✳ Baggy pants inspired by army cargo pants were in, but these new styles were made from lighter fabrics such as silks.

✳ Oversized clothing was in, like this coat.

✳ Vests, loose T-shirts, and skinny jeans typify the grunge look.

✳ A-line miniskirts were popular in the 1990s. This blue skirt has been combined with a biker jacket in pastel yellow to create an edgy look.

✳ Dr. Martens combat boots were the ultimate shoe choice of this era.

 The 1990s were the era of the supermodel! Design this supermodel's look. She has a strong pose and needs a dynamic design. Consider how the 1990s look, with its more relaxed and minimalist feel, is different to the power dressing of the 1980s.

✳ Now design a look for you!

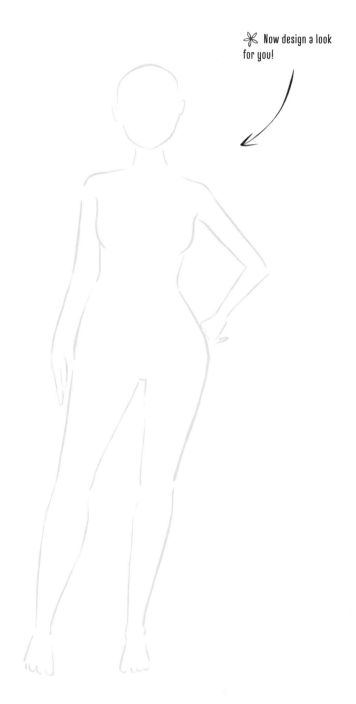

✳ Below are some grunge unisex looks. Use these looks to help you to create this model's outfit, using overalls as your starting point. What colors will you use? Is the model wearing a top under her overalls?

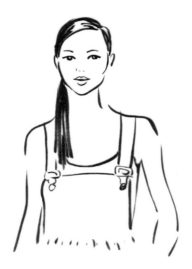

✳ Here are two ways to style your overalls.

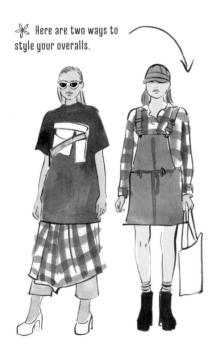

THE 2000s

This decade's fashion is often described as being a mash-up of previous decades. The hip-hop fashion trend, carried over from the 1990s, had its heyday in the earlier part of the decade, followed by the unisex indie look later on. Fashion was influenced by technology, with metallics, straps, and buckles becoming commonplace. Alexander McQueen developed the "bumster"—very low-waisted pants that showed the hipbone and hovered dangerously low. This filtered down to the mainstream with lower-waisted, and significantly more flared, jeans. Denim in general became more elaborately styled, and skinny jeans became very popular toward the end of the decade.

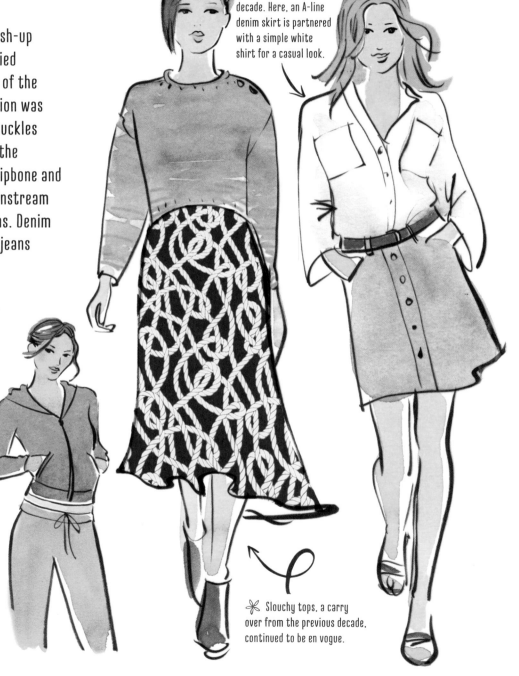

❋ Denim was ubiquitous in this decade. Here, an A-line denim skirt is partnered with a simple white shirt for a casual look.

❋ Fabrics included designer logo prints on denim and new computer-designed prints, which created unusual abstract patterns on cotton.

❋ Velour tracksuits had their moment in the early 2000s.

❋ Slouchy tops, a carry over from the previous decade, continued to be en vogue.

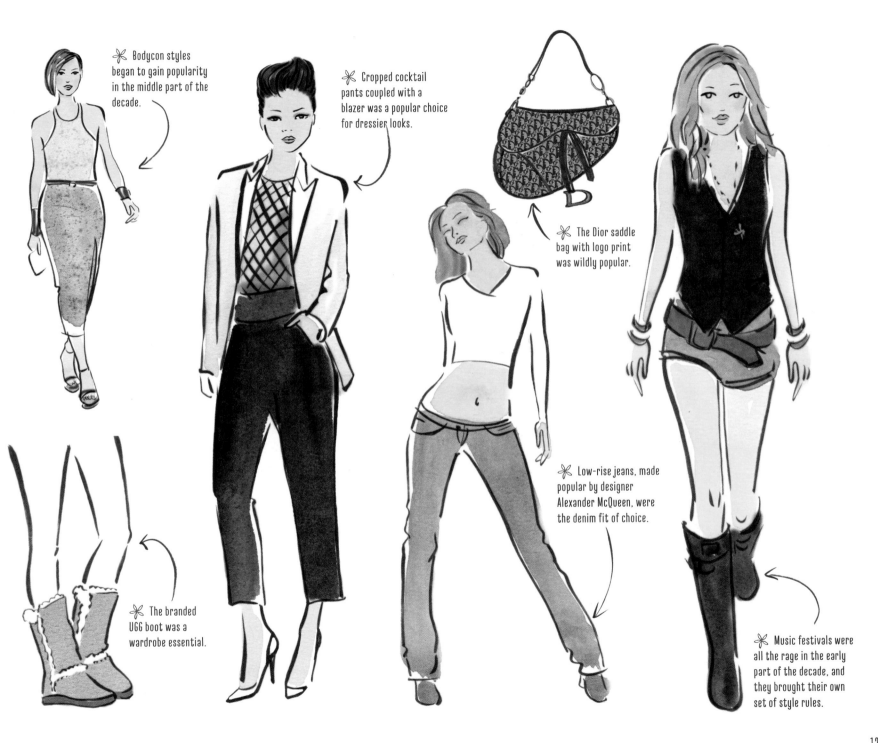

✳ Bodycon styles began to gain popularity in the middle part of the decade.

✳ Cropped cocktail pants coupled with a blazer was a popular choice for dressier looks.

✳ The Dior saddle bag with logo print was wildly popular.

✳ Low-rise jeans, made popular by designer Alexander McQueen, were the denim fit of choice.

✳ The branded UGG boot was a wardrobe essential.

✳ Music festivals were all the rage in the early part of the decade, and they brought their own set of style rules.

125

 Design a denim-inspired outfit with a nod to the cut and look of the decade. A good example of this trend is Britney Spears, with her midriff showing in bootcut jeans and a halter-neck top.

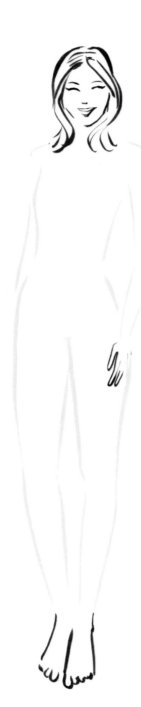

 The 2000s were a mash-up of styles plucked from the 1960s, 1970s, and 1980s. Design your own mash-up of the decades using one decade to influence your top, another to influence your bottoms, and a third to influence your accessories.

DESIGNER ICONS
COCO CHANEL

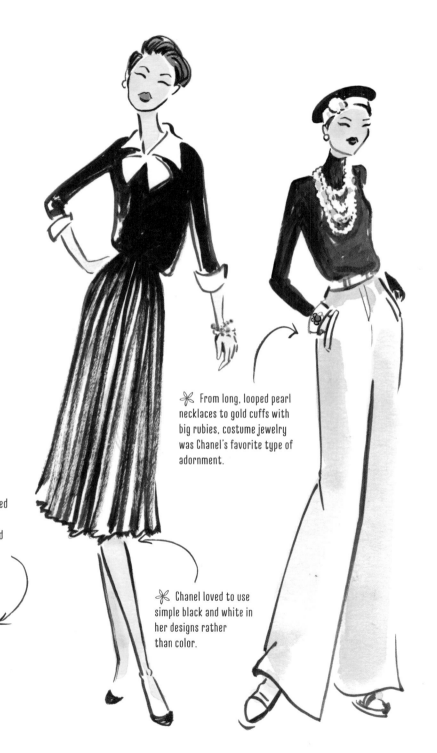

Coco Chanel (1883–1971) simplified women's fashion. She questioned the fashion norms of the early 1900s and helped to banish constricting corsets. In the 1920s she took the color black, then reserved for people in mourning, and showed how chic it could be when used in evening wear. She created the "little black dress," a staple in every designer collection. Inspired by working men's clothing, Chanel designed comfortable, elegant pieces with a timeless quality in fabrics such as jersey, silk, and tweed. At a time when women didn't wear pants, she showed just how chic they could be when partnered with the right accessories—her signature strands of pearls and costume jewelry. The Chanel jacket and bag have become synonymous with Parisian chic.

✳ From long, looped pearl necklaces to gold cuffs with big rubies, costume jewelry was Chanel's favorite type of adornment.

✳ Fabrics included tweed bouclée, upscaled houndstooth patterns, and multicolored tweed wool.

✳ Chanel loved to use simple black and white in her designs rather than color.

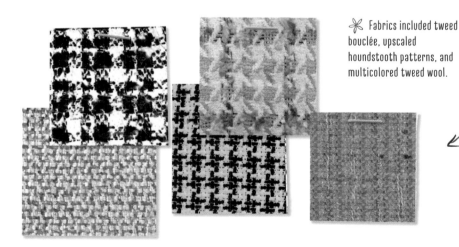

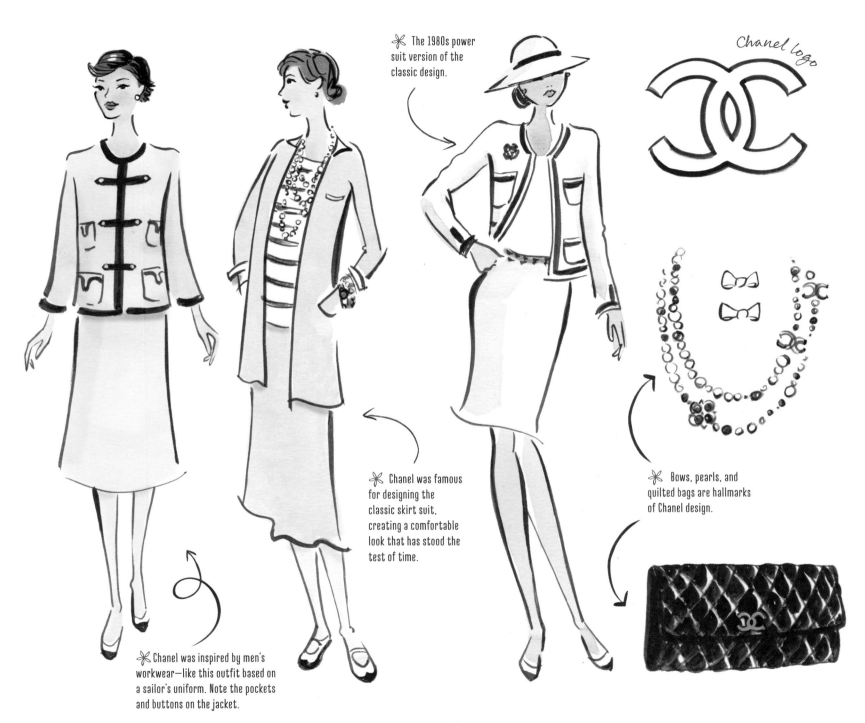

�֍ The 1980s power suit version of the classic design.

Chanel logo

✷ Chanel was famous for designing the classic skirt suit, creating a comfortable look that has stood the test of time.

✷ Bows, pearls, and quilted bags are hallmarks of Chanel design.

✷ Chanel was inspired by men's workwear—like this outfit based on a sailor's uniform. Note the pockets and buttons on the jacket.

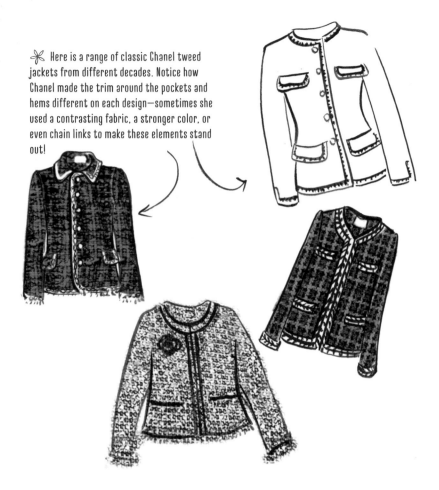

✳ Here is a range of classic Chanel tweed jackets from different decades. Notice how Chanel made the trim around the pockets and hems different on each design—sometimes she used a contrasting fabric, a stronger color, or even chain links to make these elements stand out!

✳ Design a skirt suit for this elegant model. Use a classic tweed, and consider adding a color trim. How can you make the blouse and accessories stand out?

✳ Take a modern workday uniform, e.g. delivery driver, supermarket worker, or conductor, and use it as inspiration to design a chic outfit. Consider elements from the uniform, like fit or colors, and use those qualities to create an elegant evening outfit as Chanel did with the sailor suit.

MARY QUANT

Born in 1934, Mary Quant rose to fame as a London fashion designer in the 1960s. Generally credited as the originator of the miniskirt, she designed clothes for the young generation of that time who were liberated and out to have fun. She was the same age as the women she made clothes for and knew their needs, helping to develop the "mod," "Chelsea," and "London" looks of the time. She was an arbiter of knee-high boots, patent leather, tight skinny-rib tops, and A-line dresses in bold checks and stripes. She created a doll-like look in her designs, with oversized Peter Pan collars and very short, unfitted A-line dresses that drew attention to long skinny legs.

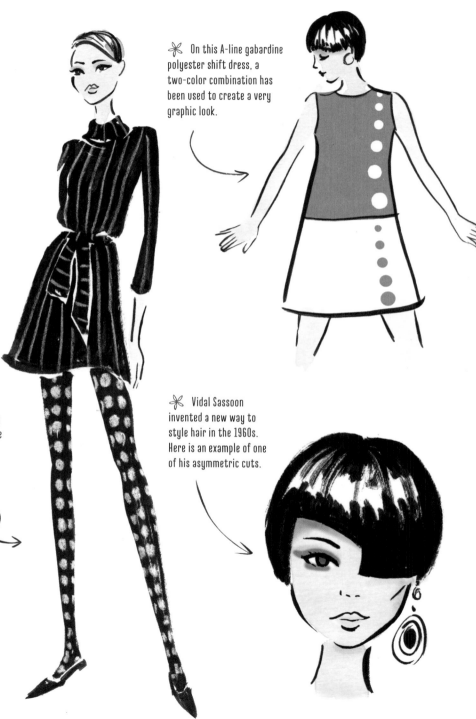

✻ On this A-line gabardine polyester shift dress, a two-color combination has been used to create a very graphic look.

✻ Lines— horizontal, vertical, zigzag—were all very popular in Mary's designs. Here they are paired nicely with polka dots in this minidress made from wool.

✻ Vidal Sassoon invented a new way to style hair in the 1960s. Here is an example of one of his asymmetric cuts.

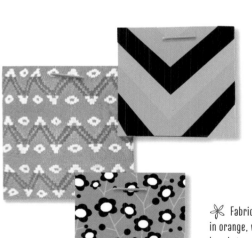

✻ Fabrics included wool knits in orange, white, and red. Quant loved strong patterns, especially created with stripes and flowers on cotton.

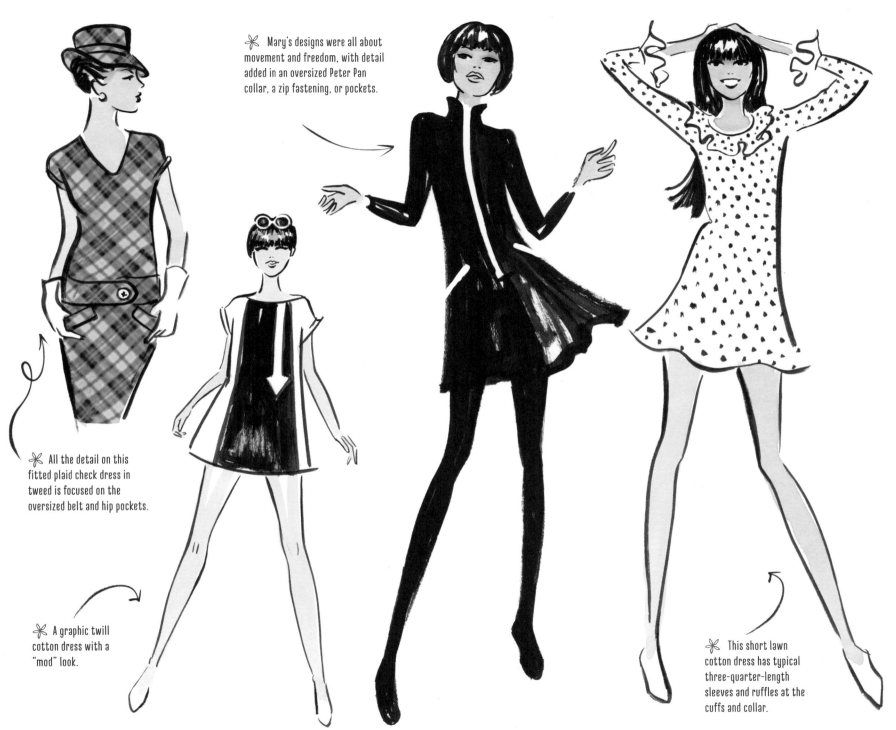

✳ Mary's designs were all about movement and freedom, with detail added in an oversized Peter Pan collar, a zip fastening, or pockets.

✳ All the detail on this fitted plaid check dress in tweed is focused on the oversized belt and hip pockets.

✳ A graphic twill cotton dress with a "mod" look.

✳ This short lawn cotton dress has typical three-quarter-length sleeves and ruffles at the cuffs and collar.

133

❋ This twill cotton shift minidress has the Mary Quant logo over-scaled. Printed on a short dress, it creates a bold, striking look.

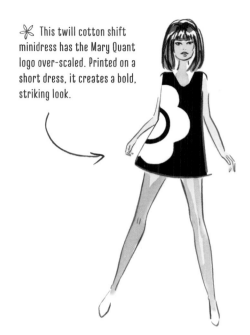

❋ Create your own Quant-esque design. Where will you place the graphic flower motif? On the pockets, or as a trim around the hem and neckline? Maybe you could design your own logo.

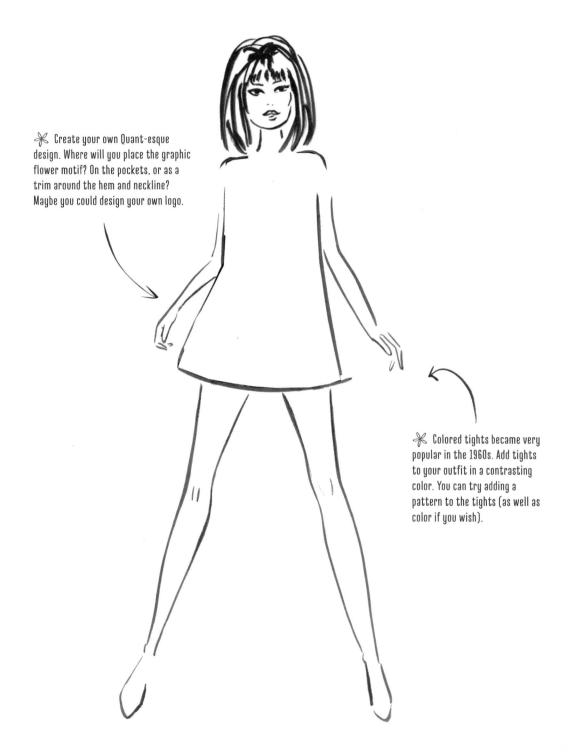

❋ Colored tights became very popular in the 1960s. Add tights to your outfit in a contrasting color. You can try adding a pattern to the tights (as well as color if you wish).

✳ Design and sketch a Quant-style dress. Remember, Quant would take just one or two details—a collar, hip pocket, or zipper—and blow up the scale. Don't forget to consider your color palette.

DONNA KARAN

When New York fashion designer Donna Karan started out creating her own collection in the 1980s, her mission was to "design modern clothes for modern people," specifically for the professional woman. Her collections were made up of mix-and-match smart, practical separates that showed off a woman's curves. The whole look became synonymous with New York. Her stretchy jersey all-black "bodysuits" (leotard-like tops and blouses that fastened under the crotch to create sleek lines without riding up or leaving fabric folds at the waist) made them the perfect no-nonsense smart clothing choices for businesswomen.

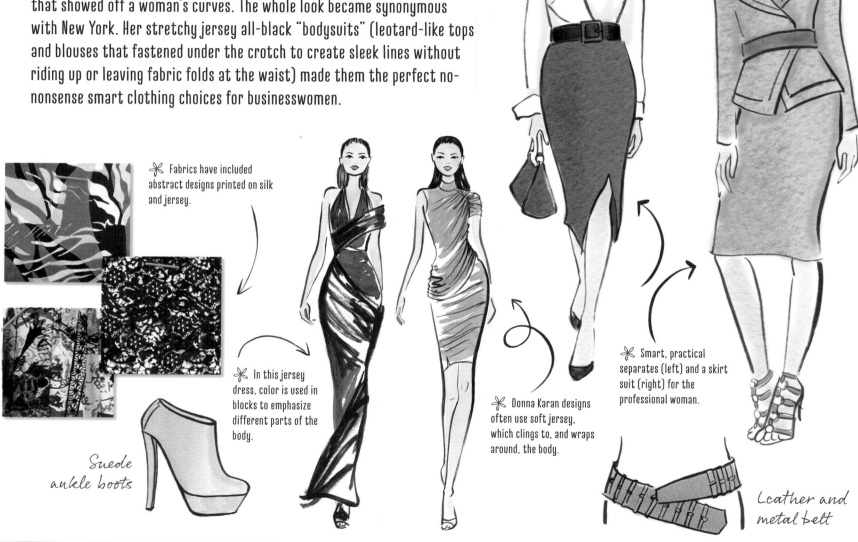

✳ Fabrics have included abstract designs printed on silk and jersey.

✳ In this jersey dress, color is used in blocks to emphasize different parts of the body.

Suede ankle boots

✳ Donna Karan designs often use soft jersey, which clings to, and wraps around, the body.

✳ Smart, practical separates (left) and a skirt suit (right) for the professional woman.

Leather and metal belt

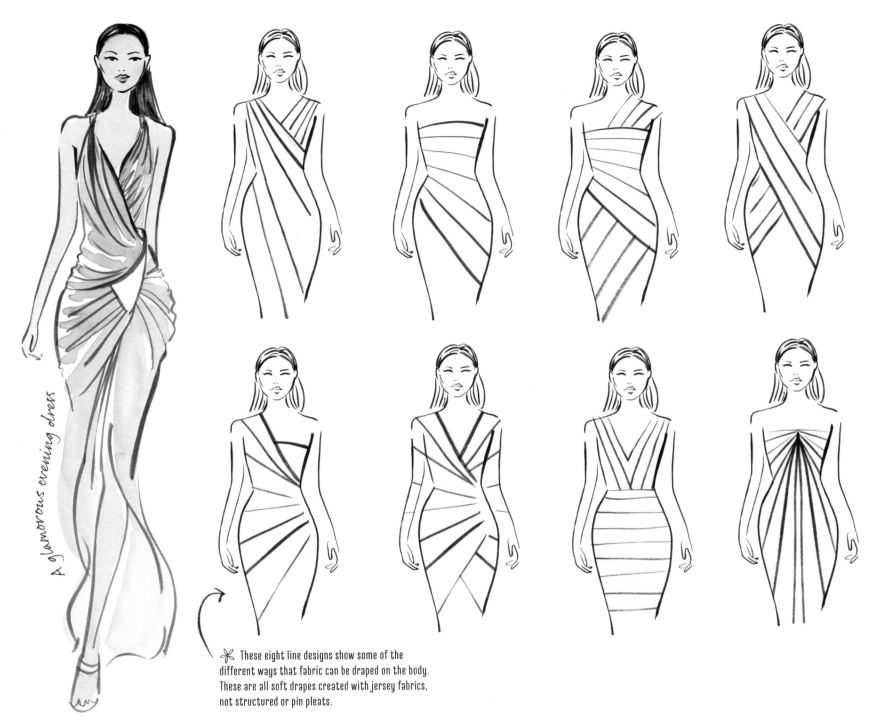

A glamorous evening dress

✻ These eight line designs show some of the different ways that fabric can be draped on the body. These are all soft drapes created with jersey fabrics, not structured or pin pleats.

✳ Design your own soft jersey Donna Karen-style dresses using the draping techniques on page 137.

✳ Design and sketch a dress in jersey. Add drapes on the diagonal across the body using different colors. To do this, first create the emphasis on the bust area, then just on the hip area. Look at page 137 for inspiration for types of drape, and don't forget the color wheel on page 24 to get more color ideas.

JEAN-PAUL GAULTIER

Born in 1952, Jean-Paul Gaultier, the "enfant terrible" of French fashion, is known for his fun, flirty, influential, and sometimes camp designs. When staring out, he drew his inspiration from edgy street style, old-school glamour, and punk. His look challenged standard views of fashion and gender. He created Madonna's famous conical bra for her Blonde Ambition World Tour in 1990, a fusion of antique and futuristic lingerie, earning new levels of attention from the general public. Another strong influence in his work is the allure of the Hollywood siren, often given a modern twist.

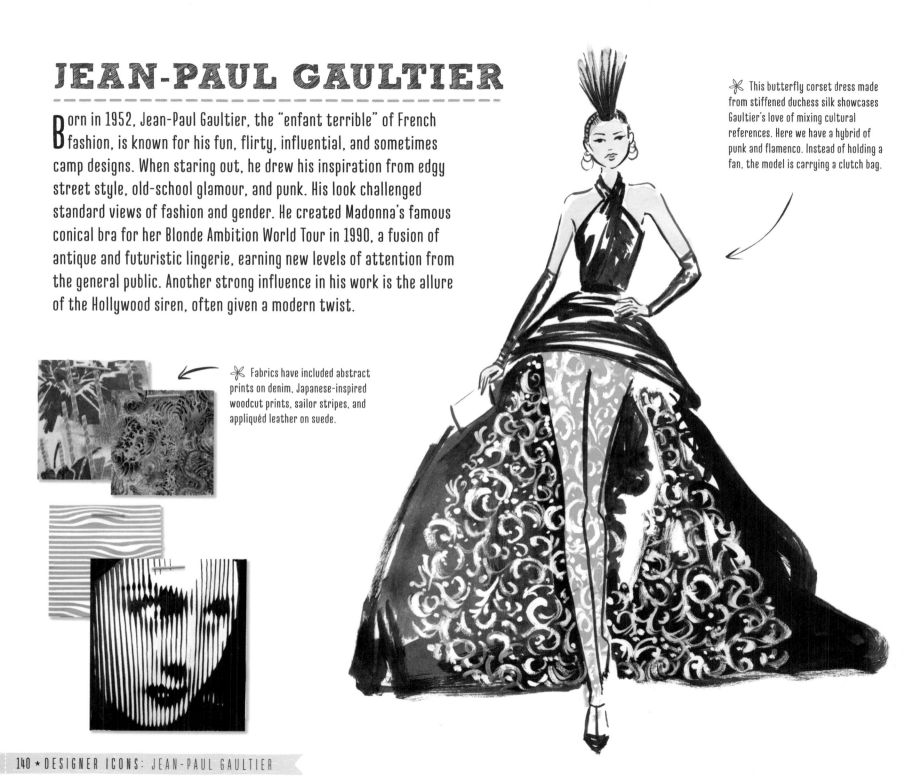

✳ This butterfly corset dress made from stiffened duchess silk showcases Gaultier's love of mixing cultural references. Here we have a hybrid of punk and flamenco. Instead of holding a fan, the model is carrying a clutch bag.

✳ Fabrics have included abstract prints on denim, Japanese-inspired woodcut prints, sailor stripes, and appliquéd leather on suede.

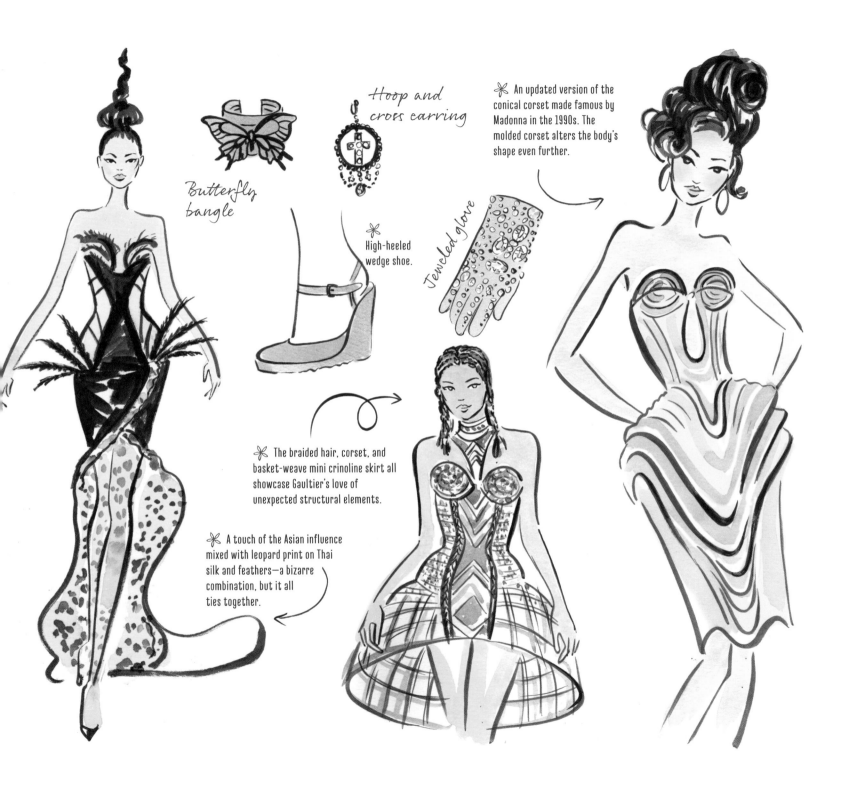

Butterfly bangle

Hoop and cross earring

✤ An updated version of the conical corset made famous by Madonna in the 1990s. The molded corset alters the body's shape even further.

✤ High-heeled wedge shoe.

Jeweled glove

✤ The braided hair, corset, and basket-weave mini crinoline skirt all showcase Gaultier's love of unexpected structural elements.

✤ A touch of the Asian influence mixed with leopard print on Thai silk and feathers—a bizarre combination, but it all ties together.

✳ Design a structured nighttime look to match the birdcage headgear.

✳ A glamorous, flirty 1950s look, with oversized butterfly wings.

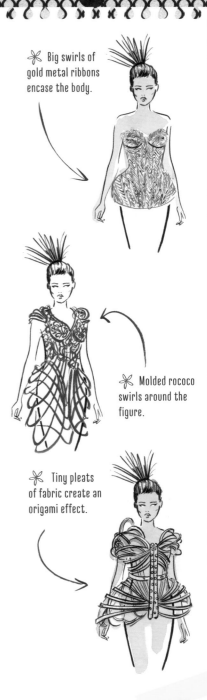

✳ Big swirls of gold metal ribbons encase the body.

✳ Molded rococo swirls around the figure.

✳ Tiny pleats of fabric create an origami effect.

✳ Gaultier has drawn from a range of styles in creating his iconic corsets: from metal cage work to basket weave, and from origami to nature. Create your own outfit using a corset frame as your base.

VIVIENNE WESTWOOD

Born in 1941, British designer Vivienne Westwood was instrumental in bringing modern punk fashion into the mainstream in the 1970s. She has constantly been ahead of the curve, not just influencing, but often dictating, fashion. After her involvement with punk group the Sex Pistols, Westwood went in an entirely new direction with her pirate collection of frilly shirts and "New Romantic" attire. Her styles have also included the "mini-crini" of the 1980s and the frayed tulle and tweed suit of the 1990s. Vivienne is famous for ripping up the pattern book—she reinvigorated the bustle and the bustier, and placed plaid in the limelight. She loves to delve into history—pirates, dandies, Native Americans, the Foreign Legion, nineteenth-century Britain, and ancient Greeks—there is barely a time period from which she hasn't plucked out a design detail to make fresh and shocking fashion!

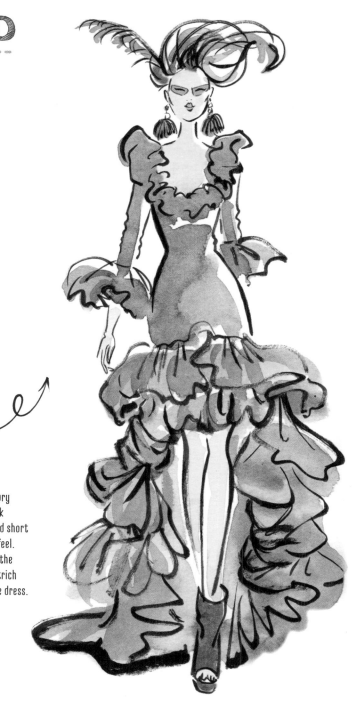

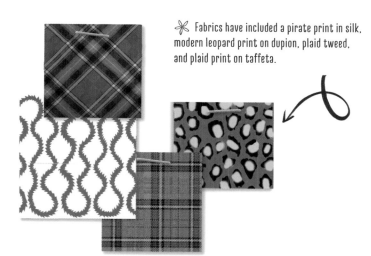

✳ Fabrics have included a pirate print in silk, modern leopard print on dupion, plaid tweed, and plaid print on taffeta.

✳ Inspired by eighteenth-century French court dresses, this blue silk dupion dress has a low neckline and short front hemline for a more modern feel. Chunky boots are added to mix up the proportions. The orange of the ostrich feathers brings out the blue of the dress.

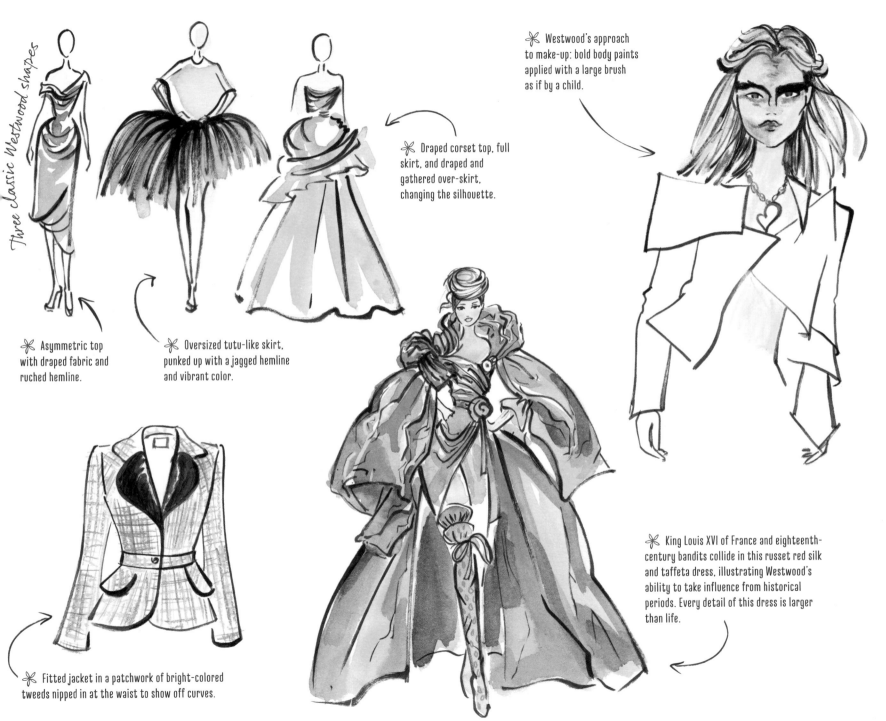

Three classic Westwood shapes

❋ Westwood's approach to make-up: bold body paints applied with a large brush as if by a child.

❋ Draped corset top, full skirt, and draped and gathered over-skirt, changing the silhouette.

❋ Asymmetric top with draped fabric and ruched hemline.

❋ Oversized tutu-like skirt, punked up with a jagged hemline and vibrant color.

❋ King Louis XVI of France and eighteenth-century bandits collide in this russet red silk and taffeta dress, illustrating Westwood's ability to take influence from historical periods. Every detail of this dress is larger than life.

❋ Fitted jacket in a patchwork of bright-colored tweeds nipped in at the waist to show off curves.

145

✳ Use the flamboyant ostrich feathers and oversized puff sleeve top as a starting point for your own Westwood-style design. Play with volume and scale, and add a pattern or two.

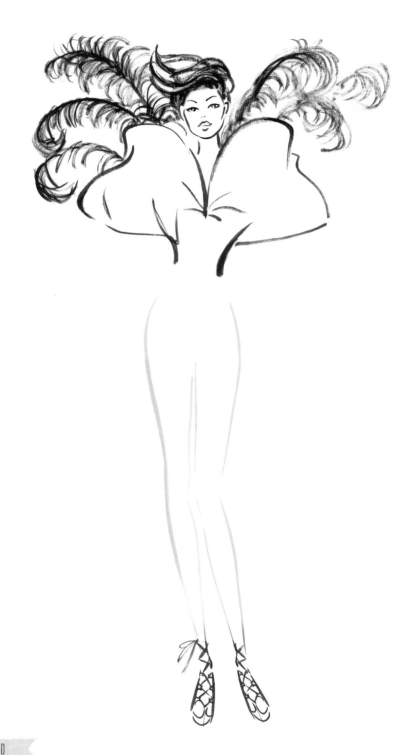

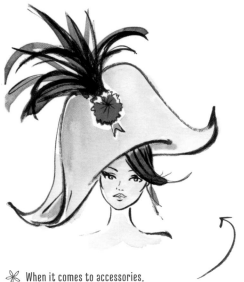

✽ When it comes to accessories, Westwood changes the scale for dramatic effect. This captain's hat has been supersized.

✽ Take your own hat design in the opposite direction, with contrasting big hair. Use the gray lines as a starting point for a bird's nest up-do and perch a tiny hat on top.

ALEXANDER McQUEEN

Designer Alexander McQueen (1969–2010) began his career working with theatrical costume designers and as an apprentice tailor in London's Savile Row. Dramatic style and sharp tailoring would later become a signature of his independent design work. Known for the flair and passion of his shows, McQueen runways featured fantastical creations: for instance, a hologram of model Kate Moss floating ethereally, or a glass box filled with moths fluttering around a naked reclining woman breathing through a strange mask. He saw beauty in women, but also wanted to show them looking strong and intimidating. His inspiration came from different cultures and the natural world. He could take an element, such as a butterfly's wing, and exaggerate the scale, making it into something powerful and alien.

✳ Fabric motifs included skulls and butterfly prints, and modern lace-effects.

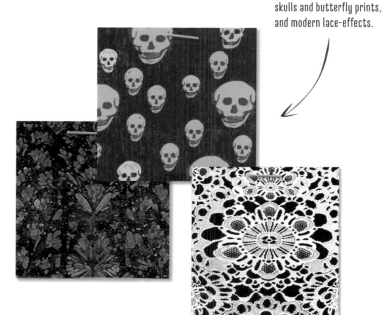

✳ This dress is created from barley stalks (woven to create the corset) and pheasant feathers (for the skirt).

✳ The fitted top of this dress is created from small rounded feathers with a tulle skirt.

✳ This dress typifies how McQueen would take ordinary natural objects (in this instance, razor clam shells) and turn them into a beautiful art form on the body. Their hard, sharp forms are suggestive of armor.

✳ A lovely surreal image—a cross between a fawn and an early twentieth-century lady.

✳ This is a skin-hugging creation printed with a scaled-up pattern from a butterfly's wing. The mask covering the head gives the figure a strange, alien quality—very typical of McQueen's work.

✳ Skull-inspired earring and ring.

✳ Design an outfit that
changes the silhouette of the
body. Take deer antlers, bird
wings, or ostrich feathers and
add them to parts of the body
to transform it in your sketch.
Try a different design for the
model on the right, utilizing
the same fantastical element.

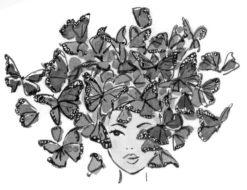

 Here are two versions of headwear: one a romantic, surreal crown of butterflies, the other a jeweled metal-link medieval armor mask.

 Choose a form from nature such as a feather, shell, butterfly wing, or animal bone, and use it to create your own headwear piece.

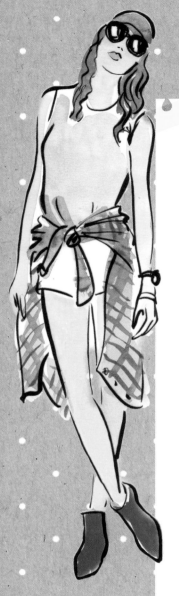

PART THREE:
SKETCH YOUR STYLE

Your personal style is constantly changing and evolving throughout your life. In this chapter, we explore some special occasions where your fashion knowhow can help you become the best-dressed person in the room. In the Style Planner section, we explore, for example, what you could wear to the theater or to a music festival. In Fashion Fantasy, you get the chance to indulge in some fantastic looks that you might not wear in real life. Choose your favorite character from a film or a book, or design your own superhero costume. The Style Journal allows you to keep a visual diary of the fashions you love and helps you to develop and create your individual style.

STYLE PLANNER
THEATER TRIP

It's time for the lights to dim and the curtain to rise. Outshine the stars on stage in your evening frock. It's all about attitude in midnight blues, velvet blacks, rustling taffeta, and strong silhouettes. Add drop diamond earrings and a necklace to sparkle and shine under the lights. Along with the glamour, comfort is important too, especially if you are watching a serious play; you don't want to be fidgeting and fiddling with your outfit all evening.

✳ This faux fur coat combats the cool night air at the end of the performance.

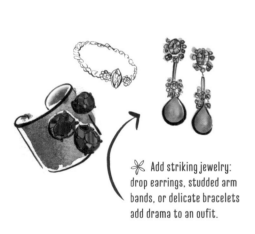

✳ Add striking jewelry: drop earrings, studded arm bands, or delicate bracelets add drama to an oufit.

✳ This corset top is full of drape and drama, just like the theater curtains.

Evening bag

Full skirt

✳ A cropped jersey top with diamond brooch coupled with a cotton full skirt with London skyline print adds just the right amount of drama for a night out.

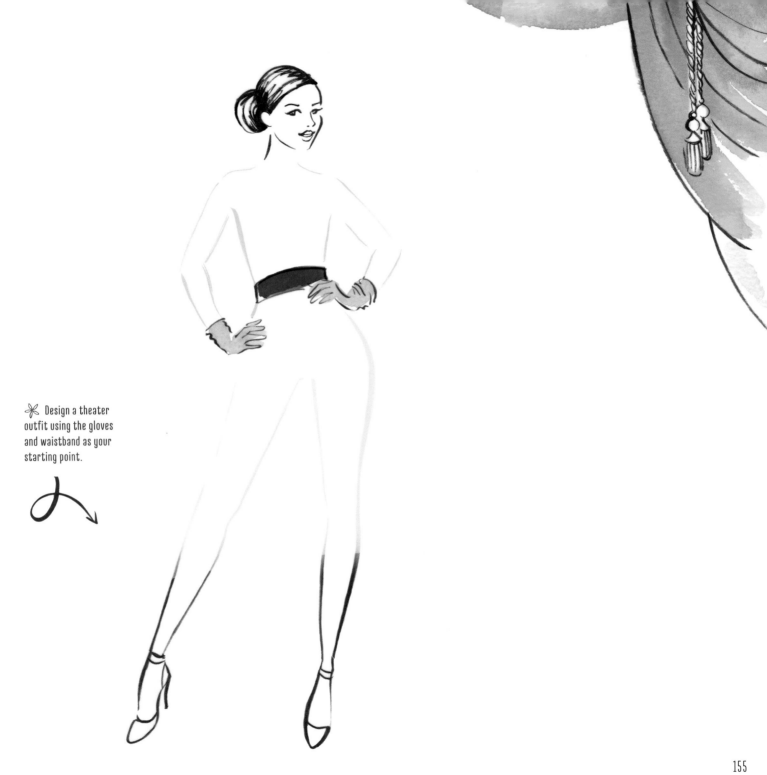

✳ Design a theater outfit using the gloves and waistband as your starting point.

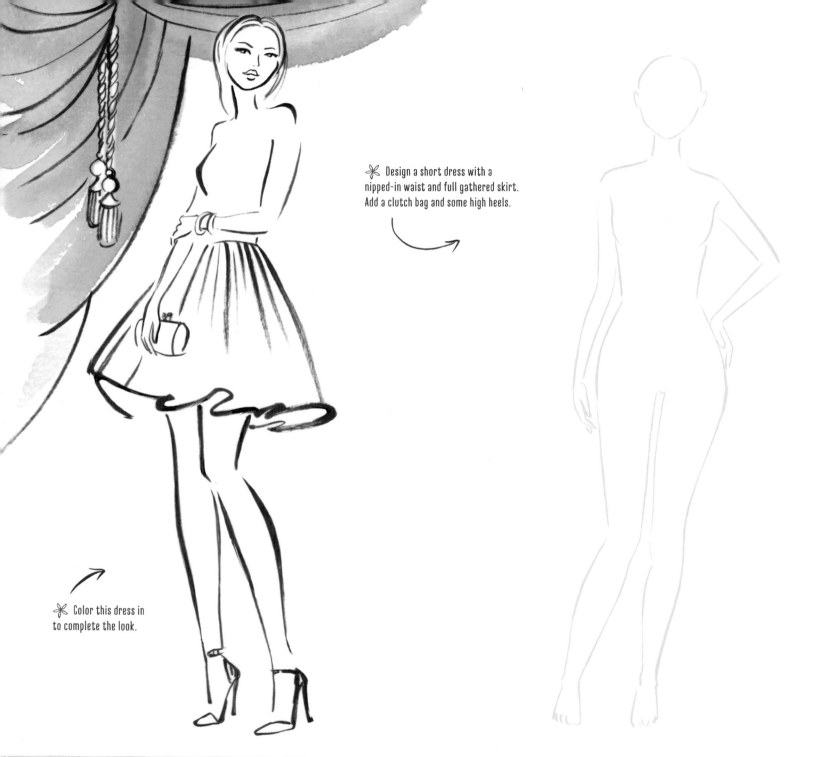

✳ Design a short dress with a
nipped-in waist and full gathered skirt.
Add a clutch bag and some high heels.

✳ Color this dress in
to complete the look.

 Design a dramatic dress for a special evening at the theater. Think about the fabric the dress is made of. Will it have embroidery or a print? What color will it be? What length will you choose? Add some striking drop earrings and a sparkly bracelet. What kind of shoes will you wear?

JOB INTERVIEW

This is a time to look your best in a smart and professional manner, whatever your vocation. Keep jewelry small and simple. Your purse should be just large enough for an iPad and resume. Classic colors that reflect the season are best—don't go too trendy with bright colors or an extreme silhouette.

✲ Classic blazer, but in a subtle color rather than black or navy.

Smart shirt dress

✲ A striking look with a silky bow blouse and a houndstooth skirt.

Pink shirt

Stud earrings

✲ Avoid statement jewelry, but a big status watch can add gravitas.

✲ Soft, pastel-colored blouses are more interesting than plain white or cream.

✲ Daring and modern asymmetric pantsuit in plum colors.

✲ You can't go wrong with a loose-fitting pantsuit in charcoal, with a white cotton blouse with black trim. Modern, but classic, the suit is made of an ultra fine wool blend for a great drape.

✲ Reading glasses make you look more serious.

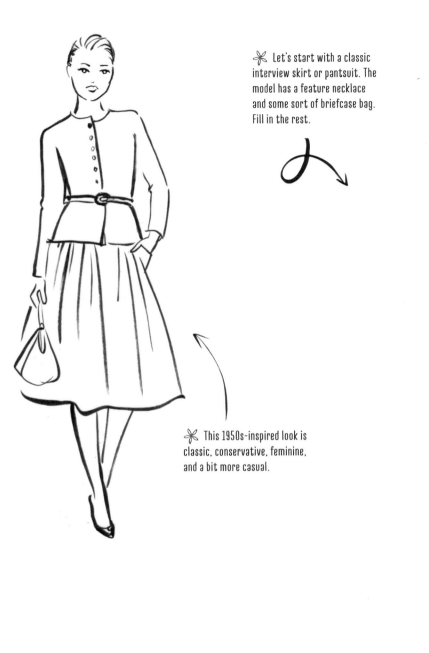

✳ Let's start with a classic interview skirt or pantsuit. The model has a feature necklace and some sort of briefcase bag. Fill in the rest.

✳ This 1950s-inspired look is classic, conservative, feminine, and a bit more casual.

 Design the rest of the outfit that would go with this blazer. You can then sketch an alternative look with a skirt or pants next to it.

 Think of what job you'd like to do and design the right outfit for the interview. Smart doesn't have to mean boring; don't be afraid to stand out from the crowd. In a line of black suits, the candidate wearing a dark beige linen suit shot with a subtle purple weave will make a lasting impression.

WEDDING GUEST

It's time to celebrate—and impress! Just remember, your outfit has to be comfortable enough to wear all night. Make a statement with a simple dress accented by bright accessories. Be inspired by the time of year and the venue—dress to reflect the location's style and grandeur. White is a no-no—and make sure you don't outshine the bride!

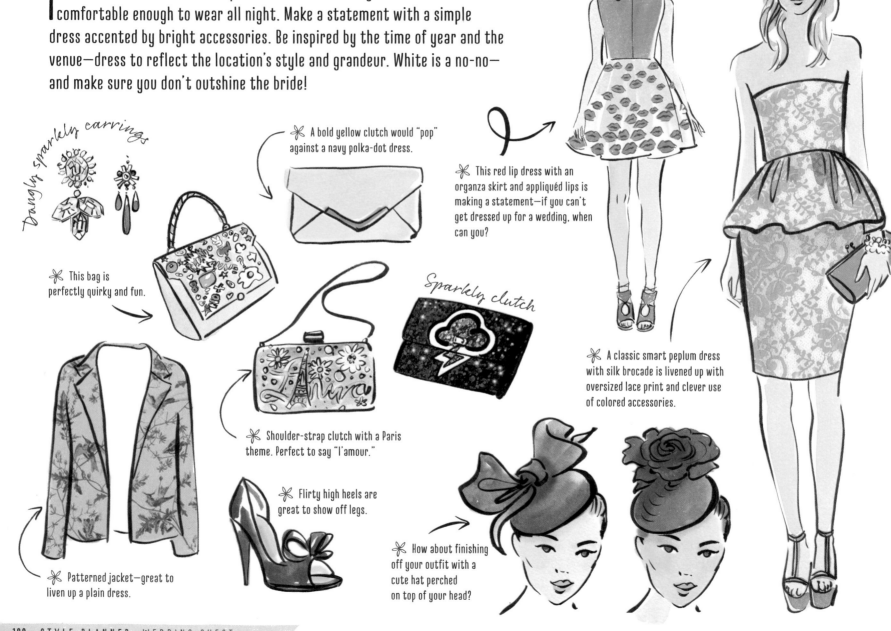

Dangly sparkly earrings

❋ A bold yellow clutch would "pop" against a navy polka-dot dress.

❋ This bag is perfectly quirky and fun.

❋ This red lip dress with an organza skirt and appliquéd lips is making a statement—if you can't get dressed up for a wedding, when can you?

Sparkly clutch

❋ Shoulder-strap clutch with a Paris theme. Perfect to say "l'amour."

❋ A classic smart peplum dress with silk brocade is livened up with oversized lace print and clever use of colored accessories.

❋ Patterned jacket—great to liven up a plain dress.

❋ Flirty high heels are great to show off legs.

❋ How about finishing off your outfit with a cute hat perched on top of your head?

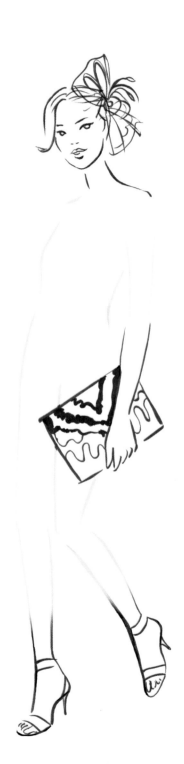

✳ This model is wearing a flamboyant bow hat and oversized abstract clutch. Design the rest of her outfit for a fun, casual wedding.

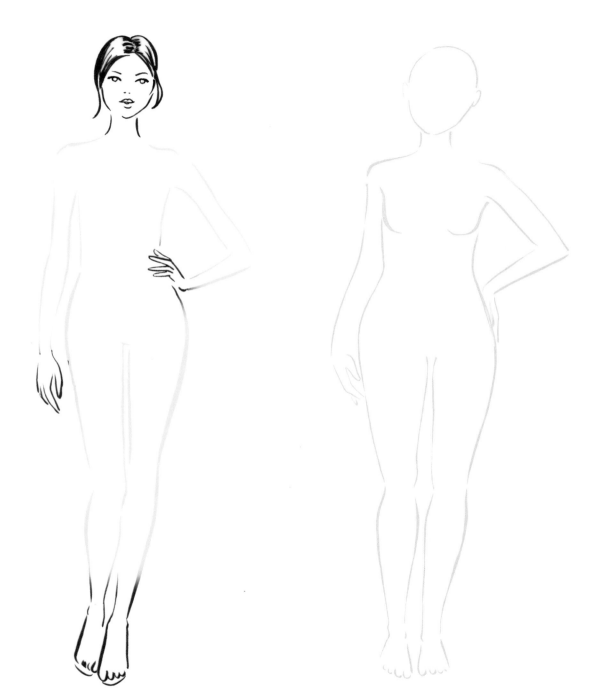

✻ Design a flattering classic outfit for a more elegant and traditional wedding. Make the bag and shoes the real "stars" of the ensemble.

✳ Imagine you've been invited to a wedding with a black-and-white theme. What could your outfit could be? Some unexpected options could include flirty polka dots, a lace print, or a black dress with white accessories. How could you sneak in a tiny bit of color?

CAMPING TRIP

On a camping trip you might have to stay dry, warm, and cool all in the same day, so think layers: warm knitwear for the cold dawn, a waterproof jacket in case it rains, and a T-shirt or tank top underneath for when you want to feel the sun on your skin while paddling in the stream. Pack clothes that make you feel at home in your surroundings, look great, and keep your own personal style all while allowing you to have fun with nature and the great outdoors!

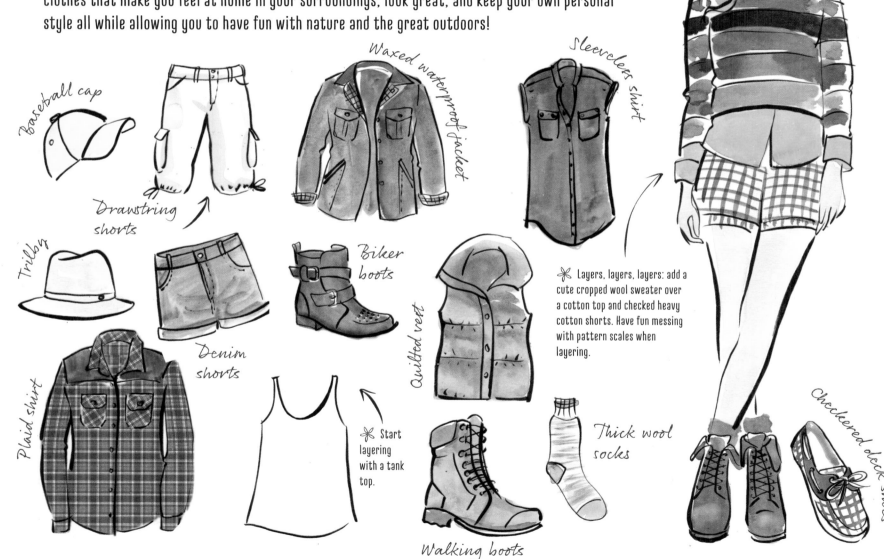

Baseball cap

Drawstring shorts

Waxed waterproof jacket

Sleeveless shirt

Trilby

Denim shorts

Biker boots

Quilted vest

✿ Layers, layers, layers: add a cute cropped wool sweater over a cotton top and checked heavy cotton shorts. Have fun messing with pattern scales when layering.

Plaid shirt

✿ Start layering with a tank top.

Thick wool socks

Checkered deck shoes

Walking boots

✳ A bandana, sunglasses, sleeveless T-shirt, and white denim shorts make for a perfect "rock" camper look.

✳ This model is wearing cargo pants—a great practical choice for camping. Design the rest of her look, making sure to consider pattern and color.

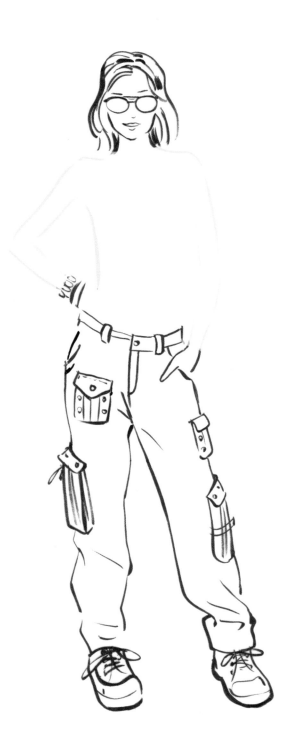

✳ Design an outfit for a summer trip in the great outdoors. Use this model for the first one, then design an alternative look next to her.

✳ Design an outfit for camping in the woods. It will be hot during the day, but when the sun goes down it will be chilly. Use lots of layers: cool cottons for the day and in the evening a big woolly hat, pants or jeans, thick socks, and hiking boots.

MUSIC FESTIVAL

The festival wardrobe is fun with a dash of practical, so it can see you through the whole day, from leaving your tent in the morning to the small hours at the chill-out stage. Layering pieces is key, so you can remove items and wrap them around your waist as you dance. Bohemian pieces shine here. Think paisley scarves, tassels, fringe, big belts, pendants, tons of bangles, and even a headdress or two. And don't forget your rain boots!

✳ A cool festival look with a panama hat to keep rain and sun off, and a practical waxed waterproof jacket over a cotton jumpsuit or shorts. Tie a denim shirt around your hips, so it's at the ready when the sun goes down.

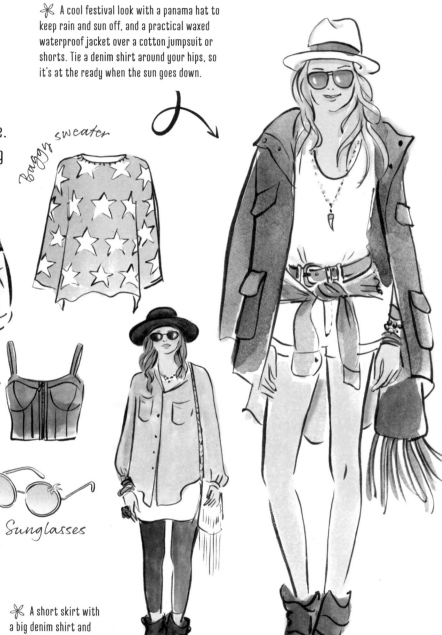

Baggy sweater

Hippy hat

Twisted top-knot hairstyles

✳ Appliqued denim cut-offs.

✳ Use a length of fabric in place of a belt.

✳ Bra tops are great for layering.

Baseball cap

Sunglasses

Cowboy boots

✳ Rain boots are always in fashion at festivals.

Ankle boots

✳ A short skirt with a big denim shirt and leggings show effortless style.

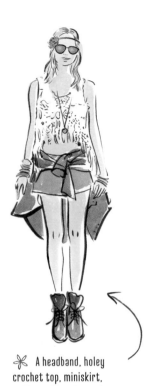

 This girl is wearing cut-off jeans with a chain belt and a pair of rain boots. Design the rest of her outfit and color it in.

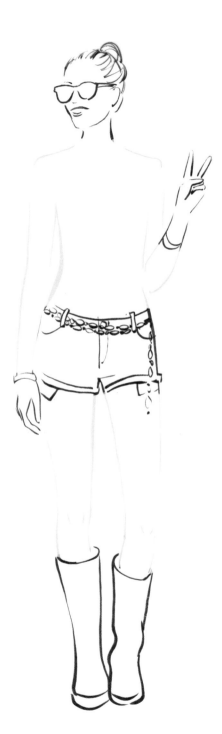

✳ A headband, holey crochet top, miniskirt, and lots of bangles make this hippie-inspired look work.

 This model keeps it casual with her hair tied back with a handkerchief and canvas sneakers. Design the rest of her outfit, playing off her casual vibe. Then sketch an alternative look next to her.

 Design an outfit for a typical music festival set outside in a muddy field. Think about adding rain boots, a hat, a parka, or a waterproof poncho: remember, you want to keep dry but still stand out from the crowd.

GOING TO THE GAME

This look is casual and, of course, sporty! Take a nod from the players' uniforms and outfit yourself for the elements—think jersey, light wools, Lycra, and denim. Start with a pretty neutral base color, like gray, and add pops of color like mint greens, pastel pinks, yellows, or your favorite team's colors. Chunky sneakers add a touch of fun, and vintage T-shirts with sports logos are a perennial favorite.

❋ Invest in a plain tank top for layering.

❋ A gray jersey dress with cut-aways is a good base for your outfit.

❋ This raglan-sleeve top is inspired by baseball uniforms.

❋ Bag with color blocking.

Brightly colored shoes

❋ A gray leather jacket with fabric sleeves will keep you cozy at chilly games.

Wedge heel boots

Baseball cap

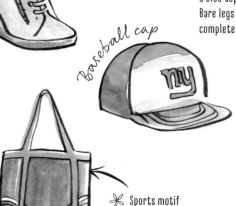

❋ Sports motif shoulder bag.

❋ This is a take on a modern sportswear outfit, but the jacket is heavily influenced by 1950s baseball jackets. The mint green color adds freshness, especially when paired with a blue top and pink clutch. Bare legs and cute sneakers complete the look.

❋ This is a mock-workout look— sporty without breaking a sweat. Combine a halter top, pink bra top, sleeveless T-shirt, and jersey hoodie, and wear over Lycra leggings and bright sneakers. Have fun mixing up the color combinations.

 A denim jacket is the ultimate wardrobe staple for watching sports. It's cool, practical, and can be dressed up or down. Design two looks: one casual daytime look and one sophisticated evening look (think dinner after the game). Draw inspiration from 1950s prom dresses or tailored pants.

✳ Think of your favorite sports team and design a modern take on an outfit for going to a game. Consider the team's colors and the weather that time of year. Try to incorporate some accessories that you already own!

✳ Now how about designing an outfit inspired by baseball or football? Try sketching a colorful silky blouson jacket with raglan sleeves, or design a new take on a sports logo and use it as a pattern for your garment.

BEACHWEAR

Beachwear is all about keeping cool and casual in the heat while still turning heads. This is the time to show off favorite parts of your body with soft, transparent fabrics and a swimsuit. Don't be afraid to take risks with bold, bright prints like those with animal or tropical motifs. Sandals, flip-flops, and gladiator sandals pair well with these casual outfits, and you'll need a big tote bag to hold all your beach essentials. Have fun with headwear: think big brimmed picture hats, Panamas, and trilbies.

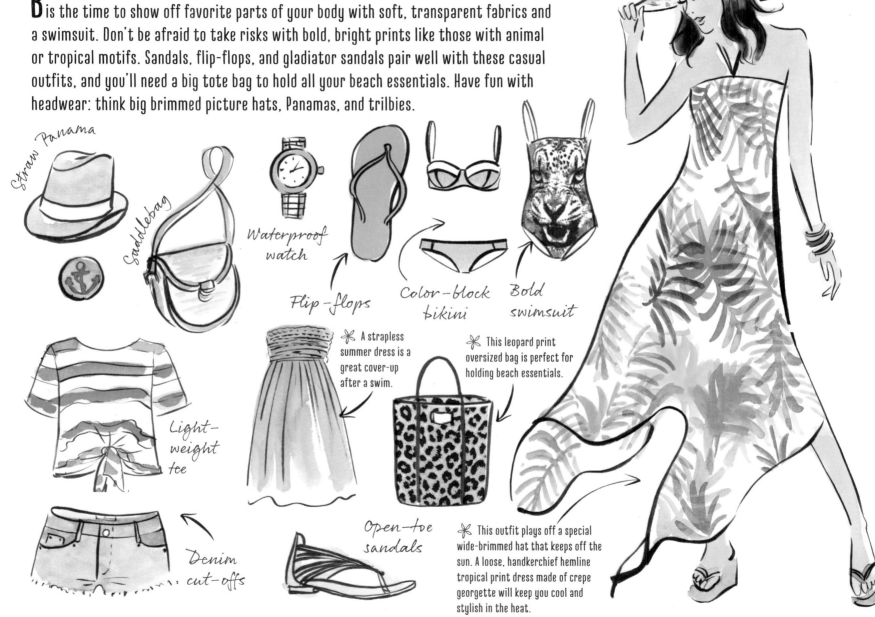

Straw Panama

Saddlebag

Waterproof watch

Flip-flops

Color-block bikini

Bold swimsuit

Light-weight tee

Denim cut-offs

Open-toe sandals

❋ A strapless summer dress is a great cover-up after a swim.

❋ This leopard print oversized bag is perfect for holding beach essentials.

❋ This outfit plays off a special wide-brimmed hat that keeps off the sun. A loose, handkerchief hemline tropical print dress made of crepe georgette will keep you cool and stylish in the heat.

✼ This lovely casual summer outfit is as much at home at the beach as at lunch with friends.

✼ This model is wearing a camisole top and a casual necklace. Design the rest of her outfit. Start with a bikini top showing underneath, and try baggy culottes, a handkerchief skirt, smart capri pants, or more casual cargo shorts for her bottom half.

 Design an outfit for a pool party. Include a swimsuit and dress or cover-up. Don't forget to add color and pattern!

✳ Design an outfit to take you from the beach to casual dinner with friends. Try to dress up the look with unique accessories like beaded sandals and a fun tote bag.

STYLE PLANNER

The next few pages have been left blank so you can plan your own outfits!

EVENT:

MY OUTFIT:

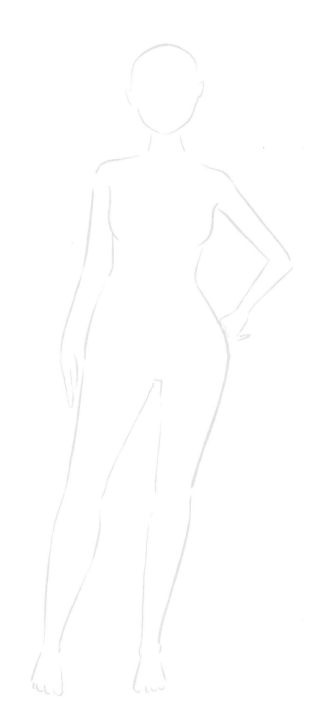

STYLE PLANNER

EVENT:

MY OUTFIT:

 Now sketch some accessories.

FASHION FANTASY
OSCAR WINNER

We're not all lucky enough to attend the Oscars... but we can dream. Awards ceremony outfits fit into a couple of categories: classic Hollywood, ultra feminine/romantic, sultry and revealing, and the wacky, arty look (think Björk in a swan dress). Think about what would suit your own personal style as you dream up your creations!

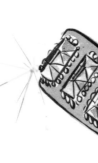

Skyscraper heels

✳ A sleek, exotic turban looks modern and glamorous.

✳ Go for a clutch that catches the audience's eye. Try one in an interesting proportion or one with oversized stones. Pair with a glamorous bracelet.

✳ A chignon up-do with oversized earrings makes for a classic look.

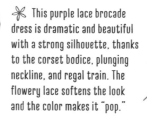

✳ Catch the lights with dazzling jewelry.

✳ This purple lace brocade dress is dramatic and beautiful with a strong silhouette, thanks to the corset bodice, plunging neckline, and regal train. The flowery lace softens the look and the color makes it "pop."

✳ This hairstyle echoes Hollywood glamour—think Turner and Veronica Lake.

✳ Oscar dresses are statement pieces, like this gold organza dress with silk flowers.

✳ Stand-out accessories are the way to go on the red carpet.

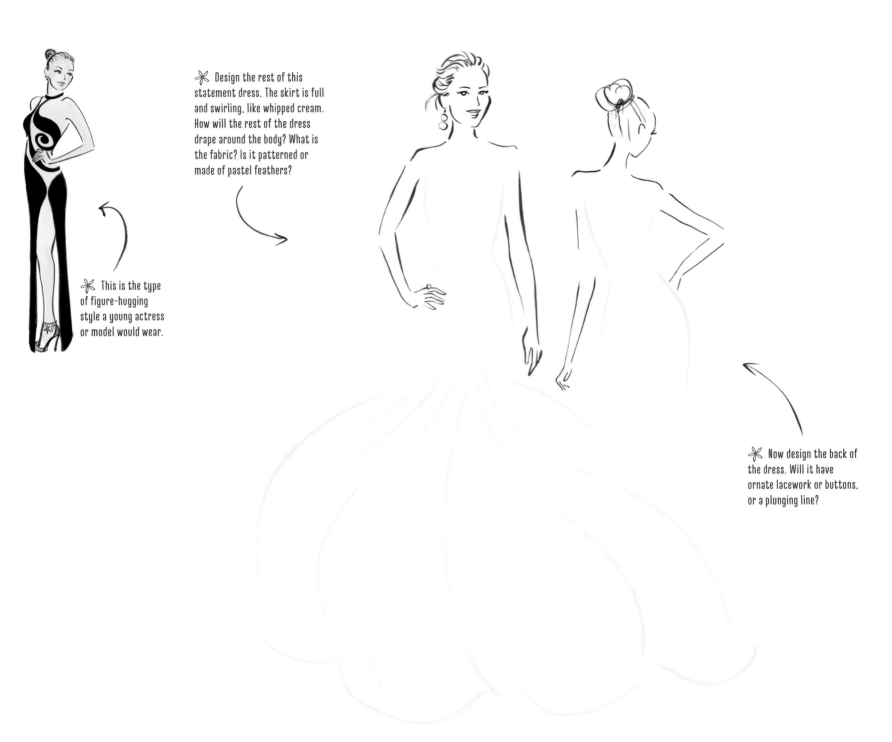

✳ Design the rest of this statement dress. The skirt is full and swirling, like whipped cream. How will the rest of the dress drape around the body? What is the fabric? Is it patterned or made of pastel feathers?

✳ This is the type of figure-hugging style a young actress or model would wear.

✳ Now design the back of the dress. Will it have ornate lacework or buttons, or a plunging line?

 Design your own fantasy gown. Think about your body shape and what color best suits you.

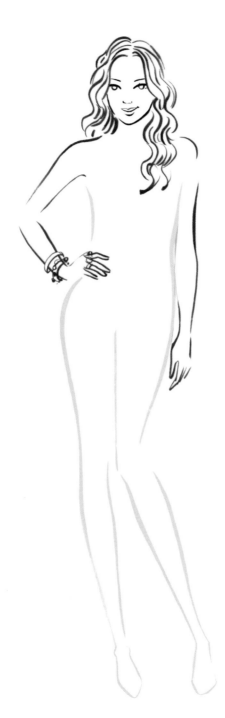

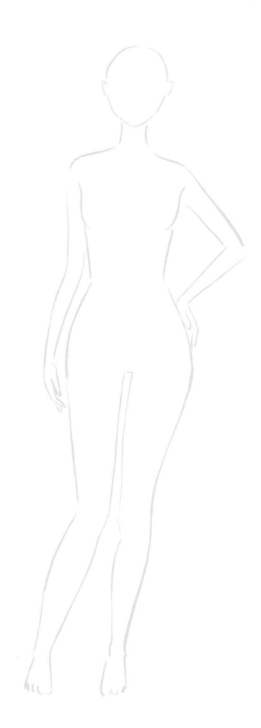

 Sketch some statement accessories to go along with your award-winning look. Think about shoes, jewelry, and clutches that will stand out and add some sparkle!

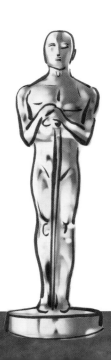

189

SUPERSTAR

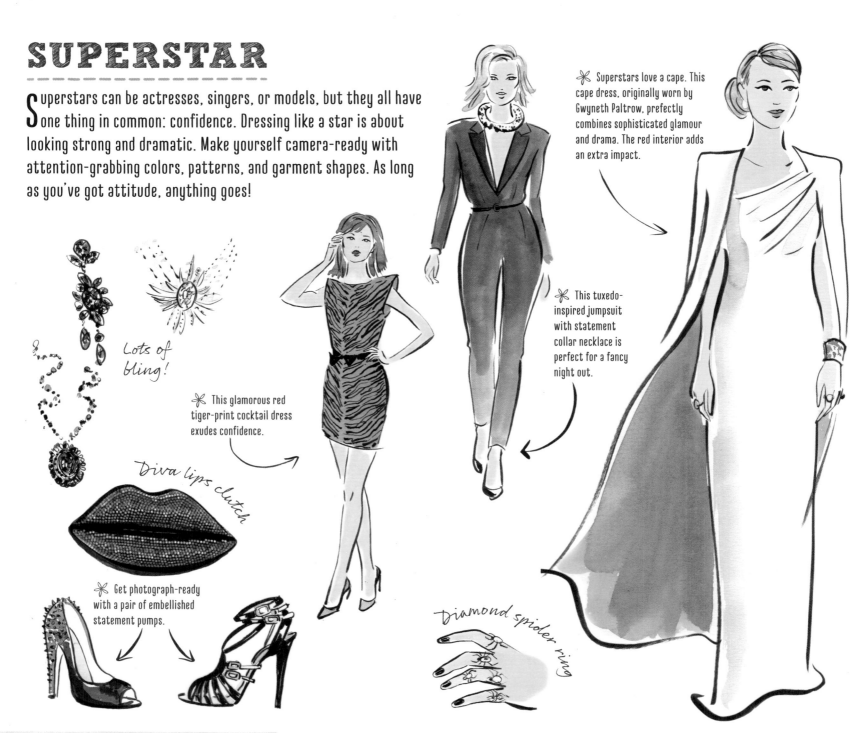

Superstars can be actresses, singers, or models, but they all have one thing in common: confidence. Dressing like a star is about looking strong and dramatic. Make yourself camera-ready with attention-grabbing colors, patterns, and garment shapes. As long as you've got attitude, anything goes!

✳ Superstars love a cape. This cape dress, originally worn by Gwyneth Paltrow, prefectly combines sophisticated glamour and drama. The red interior adds an extra impact.

Lots of bling!

✳ This glamorous red tiger-print cocktail dress exudes confidence.

Diva lips clutch

✳ This tuxedo-inspired jumpsuit with statement collar necklace is perfect for a fancy night out.

✳ Get photograph-ready with a pair of embellished statement pumps.

Diamond spider ring

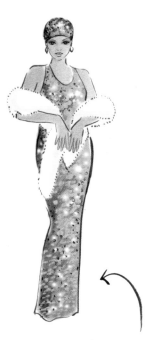

✳ This silver beaded dress with a matching cloche cap makes for a classic glam look.

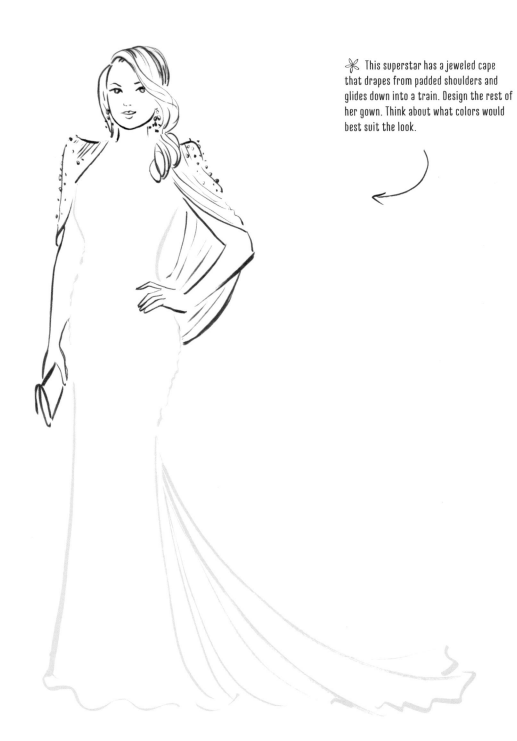

✳ This superstar has a jeweled cape that drapes from padded shoulders and glides down into a train. Design the rest of her gown. Think about what colors would best suit the look.

 Superstar dresses often have interesting details which show off the naked back. Design something for this dress to complement the lovely fishtail feature. Sketch some accessories next to it that would complete the look.

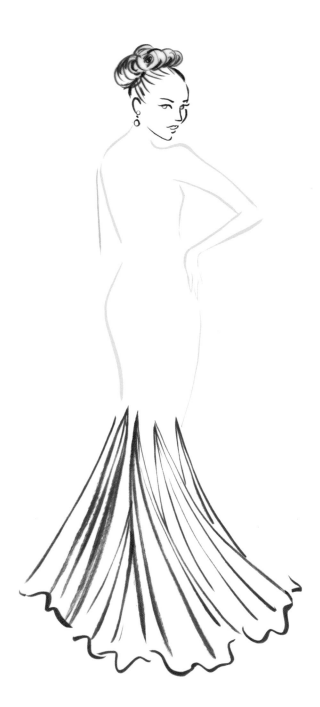

 Imagine you're a superstar in front of a crowd of admirers. Design a dress or pants look that shows off your strongest point: maybe it's your curves, your neck and shoulders, or your legs. Create something that will have impact and drama.

SUPERHERO

It's time to play the hero, whether that's Xena: Warrior Princess, Storm, or Catwoman. Fantasy characters convey strength with their architectural, and often over-the-top, ensembles. Stand-out elements include boned bodices, sculptural armlets and body armor, and, of course, a stellar mask and cape in rich primary or metallic hues. Superhero costumes are perfect for having fun with nontraditional fabrics like Lycra, leather, plastic, vinyl, and rubber.

✳ This mythical gaming costume is made out of colored latex.

✳ This Gareth Pugh black and white outfit is made of inflated rubber.

Vinyl knee-high boots

Back-sweeping masks

✳ This Iris Van Herpen dress in molded rubber is a great example of a structured superhero look.

"Superman" gold pendant

✳ Footwear is a good place to extend your logo.

✳ This Iris Van Herpen dress made out of silicon tubing seems destined for a crime-fighting costume.

✳ Masks can come in all different kinds of shapes and can be made from different materials.

✳ Video game avatars can be superheroes, too! This costume is made from plastic and vinyl.

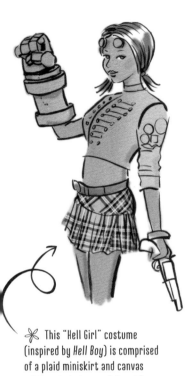

✳ This "Hell Girl" costume (inspired by *Hell Boy*) is comprised of a plaid miniskirt and canvas military jacket, complete with a polystyrene hand and lots of red body paint.

✳ This superhero has big hair and winged gloves. Design the rest of her superhero outfit (she definitely needs a mask!).

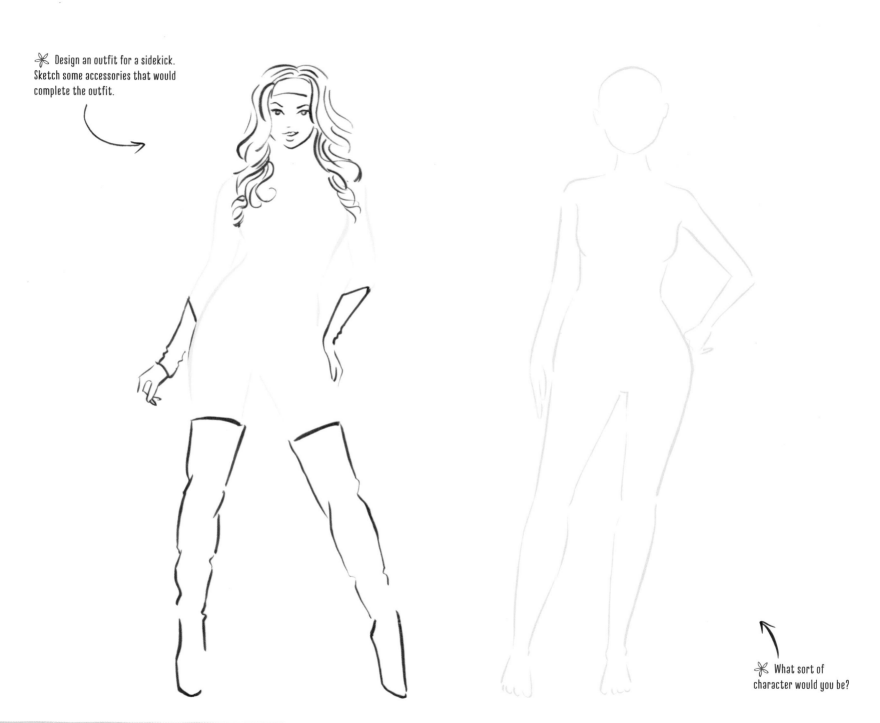

✳ Design an outfit for a sidekick. Sketch some accessories that would complete the outfit.

✳ What sort of character would you be?

❋ Design an outfit based on one of your favorite characters but switch up the colors and textures from the original. Think hard about the accessories: mask or make-up (how much does it cover, just the eyes or more of the face?), gloves (are they made of rubber and an interesting shape?), and boots (are they high-heel, zip-up, knee-high?).

POWER DRESSING

Perfect for a CEO or attending business meetings, power dressing is about being commanding, confident, and smart. The looks should be modern and structured, but still exude femininity. Think timeless looks with modern twists. Keep the accessories classic both in their lines and colors.

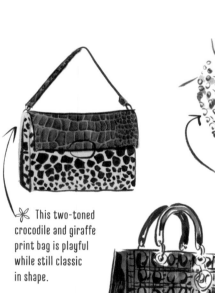

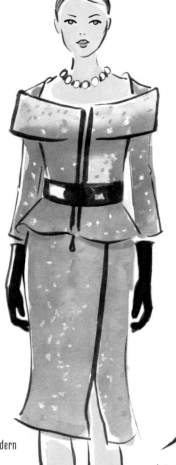

❋ This two-toned crocodile and giraffe print bag is playful while still classic in shape.

❋ Multilayered pearl necklace and statement drop earrings—timeless with a twist.

❋ A black leather embossed bag is a winning choice for any power look.

❋ Suits don't have to be stuffy. This modern structured suit in gray wool has a small conservative slit in its three-quarter-length skirt.

❋ This sleeveless dress has a classic shape, but the color panelling gives it some edge.

Low-heeled shoe

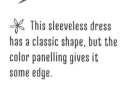

Structured sandal

✳ Design the rest of the model's gown for an important corporate or state function. It needs to be glamorous but not too revealing. Think about using different fabric drawing techniques to play with volume and proportion.

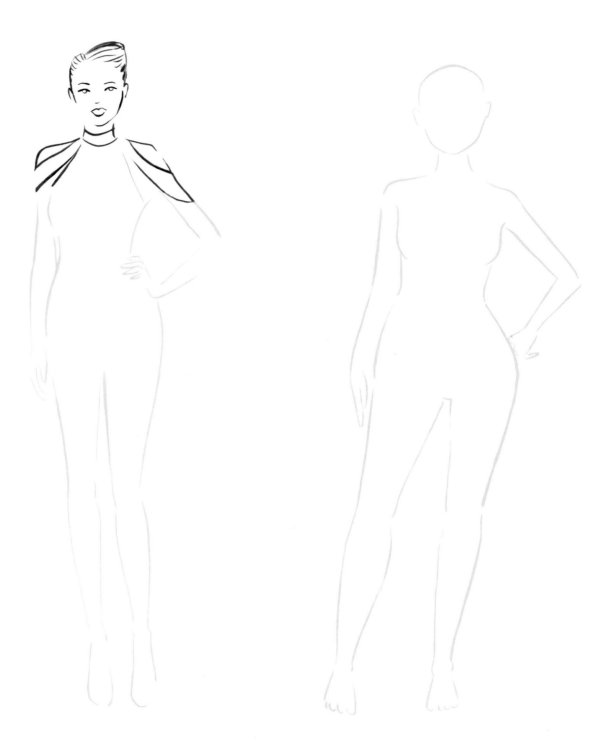

✳ Design a modern suit in an
interesting color. Think about
proportion and fabric to give it
structure, but play around with
necklines, hemlines, and embellishments
to bring it into the present.

✳ A power outfit isn't complete without strong accessories.
Sketch some shoes, jewelry, and bags to finish off your look.

WEDDING DRESS

It's the big day, so think big! Weddings are the time to flaunt your personal style in a grand way, whether that's more Disney princess, full and floaty, lacy antique, or slinky bias-cut silk. Although wedding gowns are typically white or ivory, modern brides are branching out into blush, vivid purple, or even bold plaid. Shoes vary according to the dress's style and length: if it's floor length, go for drama with high heels; if it's a 1950s prom-style dress, then a low open-toe heel is more appropriate. Either way, have fun experimenting!

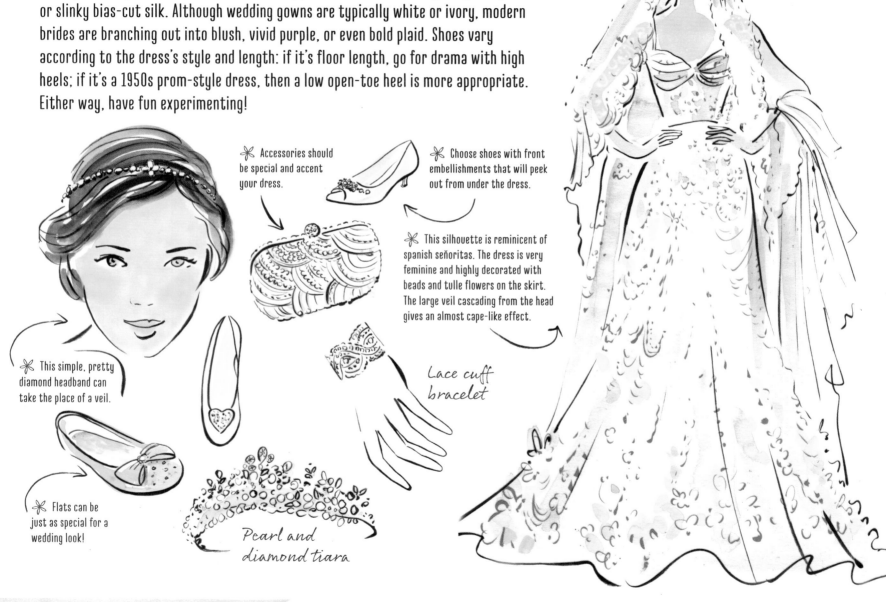

✽ Accessories should be special and accent your dress.

✽ Choose shoes with front embellishments that will peek out from under the dress.

✽ This silhouette is reminicent of spanish señoritas. The dress is very feminine and highly decorated with beads and tulle flowers on the skirt. The large veil cascading from the head gives an almost cape-like effect.

✽ This simple, pretty diamond headband can take the place of a veil.

Lace cuff bracelet

✽ Flats can be just as special for a wedding look!

Pearl and diamond tiara

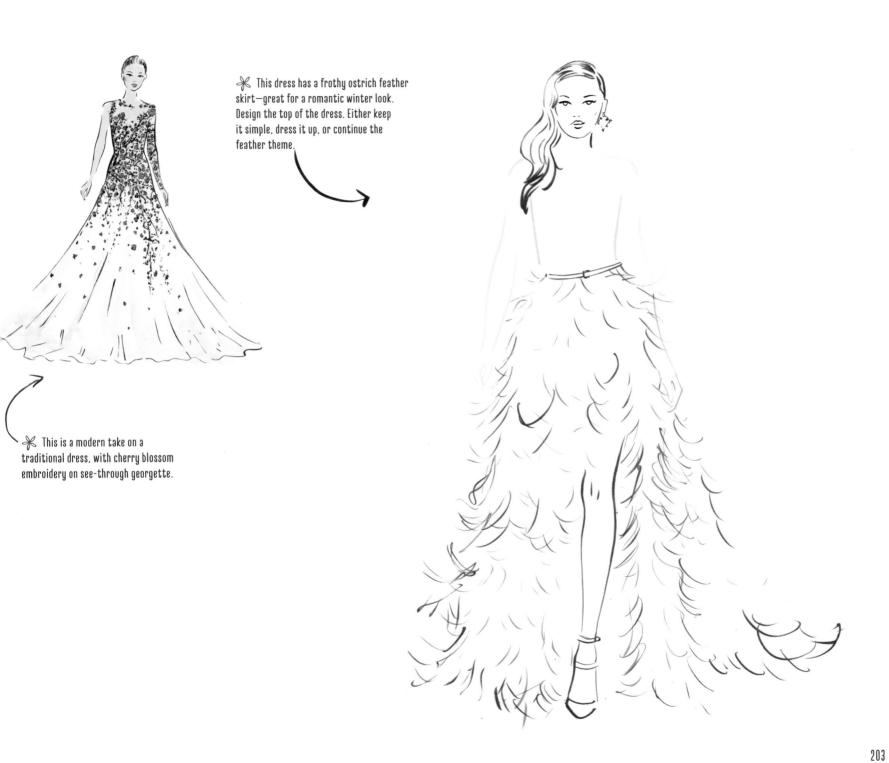

✳ This dress has a frothy ostrich feather skirt—great for a romantic winter look. Design the top of the dress. Either keep it simple, dress it up, or continue the feather theme.

✳ This is a modern take on a traditional dress, with cherry blossom embroidery on see-through georgette.

 On this model, think about pushing the boundaries on what is considered a wedding dress. Try playing around with color and hem lengths to create a unique look.

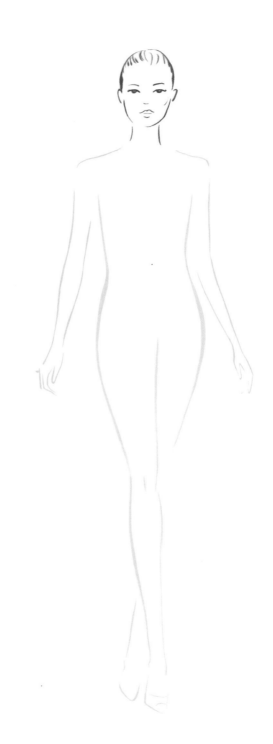

✳ Design a dress with a close friend as your client. Think about what she'd like to be seen in to show off her best features and capture her personality.

YOUR OWN
FASHION FANTASIES

U se the following pages to induldge
your own fashion fantasies.

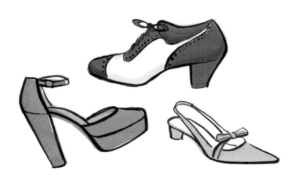

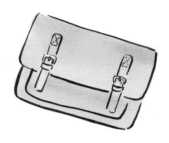

STYLE JOURNAL

In this section, use your own style and wardrobe as your inspiration by recording the outfits and looks you have created—from casual days and nights out, to trips to the beach or a restaurant. Keep a journal of the styles that you think are creative, or pick out street-style looks that show real panache, like someone you see waiting at the bus stop on a cold morning who is rocking a structured wool coat with a brightly colored oversized beanie, or might be at a music festival and there is something about your friend's outfit that makes it extra special. Try and sketch it in your journal and see if you can work out what makes it great. This is what all good designers do on a daily basis when trying to design a new collection: they keep their eyes peeled for great ideas and inspiration.

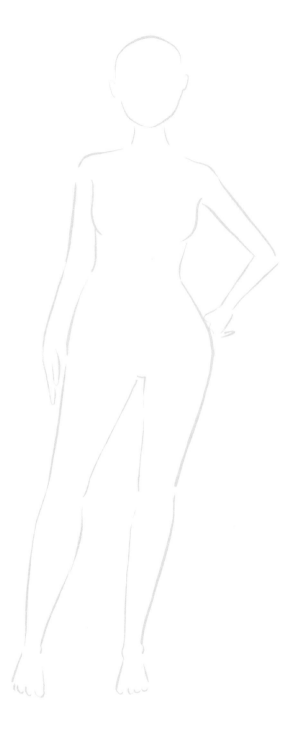

STYLE JOURNAL

DATE:

WHERE I WAS:

THE INSPIRATION:

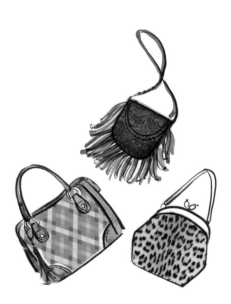

STYLE JOURNAL

DATE:

WHERE I WAS:

THE INSPIRATION:

STYLE JOURNAL

DATE:

WHERE I WAS:

THE INSPIRATION:

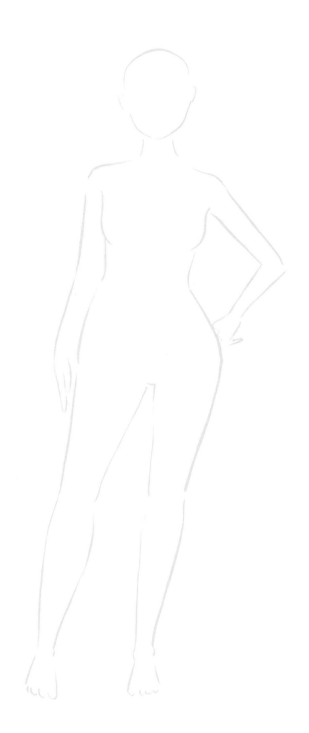

STYLE JOURNAL

DATE:

WHERE I WAS:

THE INSPIRATION:

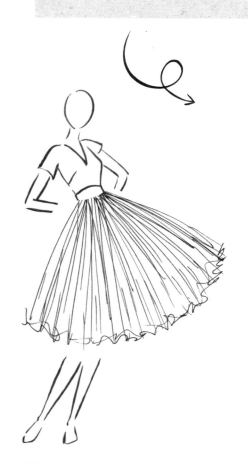

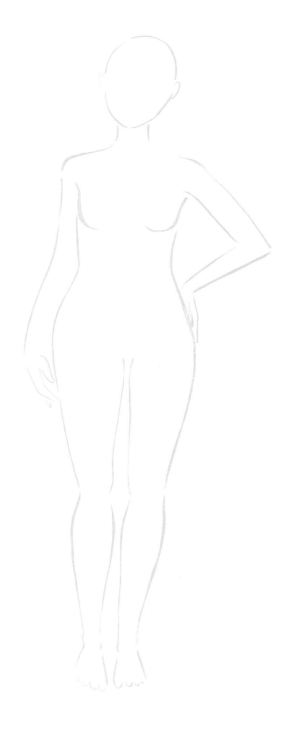

STYLE JOURNAL

DATE:

WHERE I WAS:

THE INSPIRATION:

STYLE JOURNAL

DATE:

WHERE I WAS:

THE INSPIRATION:

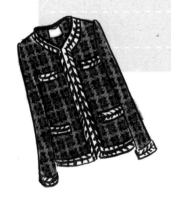